Ashmolean handbooks

Twentieth century paintings

in the Ashmolean Museum

Katharine Eustace

Ashmolean Museum Oxford
1999

Acknowledgements

The author would like to thank her husband James Hamilton, her colleagues Vera Magyar, Judith Salmon, Anne Steinberg, Catherine Whistler and Jon Whiteley; Eunice Martin and Linda Whiteley of the Western Art Library, and staff of the Tate Gallery Library.

British Library Cataloguing in Publication Data
A catalogue record for this book is available from the British Library

Cover illustration: Mark Gertler, *Gilbert Cannan and his Mill*, no. 11

Designed and typeset in Versailles by Roy Cole
Printed and bound in Singapore by Craft Print Pte Ltd

Foreword

The Ashmolean Museum is famous throughout the world for its unequalled collections of Egyptian statuary, Chinese bronzes, Renaissance drawings and Minoan antiquities. It is not famous for its collection of modern art and yet, as this handbook makes clear, it is rich in British painting of the twentieth century and has notable French and Spanish paintings, among them major works by Braque, Matisse and Picasso.

In the past, the Ashmolean has been able to display only a small part of this important collection because of pressure of space and, recognising this unhappy situation, the Heritage Lottery Fund has made a substantial grant to the Museum to enable a gallery of twentieth century art to be built. It will open in the autumn of 2000. We are profoundly grateful to the Trustees of the Fund for their support of the Ashmolean. This handbook to the collection by my colleague Kate Eustace will serve as an introduction to the collection of twentieth century art and give the reader a sense of the outstanding quality of what we will be able to put on public display when the new gallery opens.

Dr Christopher Brown
Director
February 1999

Introduction

Within its limited scope this handbook gives a taste of a century of ceaselessly changing artistic activity. Among the collection's great strengths is the important representative group of Camden Town and Euston Road School paintings, and the Gertlers. The collection does not, however, reflect all the great shockwaves of change: there is no Surrealism, for example, while the great visual dilemma between abstraction and figuration is almost completely unrepresented.

While some of the great names of the early twentieth century – Picasso, Braque, Matisse – are represented in the collection, the paintings themselves are often atypical of these artists' work. Yet there is a common denominator – many are early works and most are transitional, often painted at a time at which the artist was finding his or her own 'voice', or even on the cusp of a change of direction. Thus they are not characteristic of their artist's mature work. *Picasso's *Blue Roofs* and *Pasmore's *Snowscape* are examples of this tendency, as are the *Kandinsky, the *Bonnard and the *Philpot.

*in the text denotes an entry in this book

Probably because of the nature of the Ashmolean's collections, rooted as they are in the classical tradition, the evolution of the twentieth century collection has not been consistent. Instead it has occurred in leaps and starts, many of them premature. There has never been an identifiable curatorial policy to collect twentieth century paintings, and the collection's growth has been almost entirely dependent on the generosity of individuals.

The first serious impulse to collect twentieth century art came at the end of the 1930s with two spectacular bequests. Mrs W.F.R. Weldon [Fig 1]

Fig 1
Mrs W.F.R. Weldon, Richard Murry, 1928

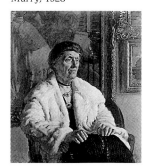

4

who had already presented a number of important old master paintings, including Claude Lorrain's *Landscape with Ascanius Shooting the Stag of Sylvia*, bequeathed fifty paintings and thirty drawings. Though consisting largely of French nineteenth century works, the Weldon Bequest also included drawings by *Augustus John, Rex Whistler and Bernard Meninsky, and paintings by Sir William Rothenstein, Gilbert Spencer and *Nevinson.

The Weldon Bequest was followed almost immediately by that of Frank Hindley Smith. This bequest was shared with the Fitzwilliam Museum, Cambridge, and with museums in Exeter, Bolton, Norwich and Peterborough. The Ashmolean's portion included some of the most important paintings in the collection, Picasso's *Blue Roofs*, *Sickert's *Ennui*, and what is probably the earliest *Braque to enter a public collection in Britain. Frank Hindley Smith is a little known figure who appears in the margins of collected letters and other people's biographies of the period. Very shy and something of a recluse, he came from a Lancashire cotton-milling family, and ran the firm of Darcy Lever in Bolton. His name was proposed for a peerage when Asquith planned to swamp the House of Lords in 1911. Hindley Smith's tastes seem to have developed, like that of his contemporaries Sir Michael Sadler and Sir Samuel Courtauld from a love of Spanish and Italian old master painting via nineteenth century French painters including Corot, Manet, Renoir and Lautrec. This progression led him to such contemporary works as Matisse's *Sur le Sofa*, bought at the Goupil Gallery in 1920, the year after it was painted, for £420, and Braque's *Le Paquet de Tabac*, bought at the Lefèvre Gallery in 1933.

The growth in Hindley Smith's taste almost certainly reflects that of his dealer and mentor, Percy Moore Turner, who also advised Sadler and Courtauld. Before the First World War Turner ran the Barbazanges Gallery in Paris, where Roger Fry and Desmond McCarthy had visited him in search of Post-Impressionists. After the war, Turner opened

the Independent Gallery in London, specifically to promote the work of young living artists. Turner was Hindley Smith's executor, and it was almost certainly he who was the guiding spirit behind the decision to leave the bulk of his collection to the two University museums of Oxford and Cambridge. When Turner's own bequest of Burgundian sculpture, seventeenth century paintings and nineteenth century French drawings came to the Ashmolean in 1952 one of his executors recorded that 'Turner was devoted to the Ashmolean', that he felt some gratitude to past curators Charles Bell, Kenneth Clark and Karl Parker and that 'also he minded about the young.'

Hindley Smith's interest in the contemporary was undoubtedly encouraged by an acquaintance with Roger Fry, made through Turner, probably in 1920. Fry described how it came about in a letter to Marie Mauron in 1921. It was fostered by Hindley Smith when Fry stayed with him at 39 Westborne Road, Birkdale, Lancashire, 'by the sea among sand dunes as on the Dutch coast – a splendid house with every possible comfort and not at all pretentious.' There they discovered their mutual admiration for Proust and French paintings, and played golf. Fry returned to stay with Hindley Smith when touring the north to give lectures, and, in 1923, painted his portrait (Fig 2). Hindley Smith retired to Seaford in Sussex, where he built a modernist house for himself and his collection. At Seaford he was near to Firle, where members of the Bloomsbury Group had settled. Hindley Smith entertained the Bloomsbury artists and writers to musical soirées on his 'magnificent player-piano', as Duncan Grant later recalled. He bought works by Fry, Grant and Bell and their friend Segonzac. With Maynard Keynes and Samuel Courtauld he undertook to be a guarantor of a scheme to support artists through the London Artists' Association, a quasi-charitable act remembered years later by Vanessa Bell with affection, and by *William Roberts with bitterness. Hindley Smith's bequest to the Ashmolean came, as Frank Davis

Fig 2
Frank Hindley Smith, Roger Fry, 1923 (detail)

6

wrote in the *Illustrated London News* (16 March 1940), with the intention of making the pictures 'available to every one of his fellow citizens', distributed throughout the country 'in such a way as to give as much pleasure as possible.'

In the years following the Second World War, when contemporary art was given official encouragement to an unprecedented degree, an anonymous gift of seven works by young aspirant artists of the Euston Road School, among them *Victor Pasmore, William Coldstream, Rodrigo Moynihan and Claude Rogers, brought the collections right up to date. The fact that the gift was anonymous was regrettable because it left the paintings without an historical context. The anonymity, however, has recently been set aside, and it is illuminating to discover that the generous benefactor was the painter John Dodgson (1890–1969), a nephew of Campbell Dodgson, Keeper of Prints and Drawings at the British Museum, and a collateral of the Rev. Charles Dodgson (Lewis Carroll). John Dodgson had been a godfather to the young painters, raising money and materials for their school at 319 Euston Road, which gave its name to a style.

Thomas Balston (1883–1967) (Fig 3) was a member of the Whatman paper-making dynasty, and from 1921 to 1934 worked for the publishing house Duckworth & Co. There he initiated an innovative policy of employing wood engravers as illustrators, taking full advantage of the revival of the medium in the 1920s. His bequest in 1967 was presented through the National Art Collections Fund and was, like Hindley Smith's bequest, shared with the Fitzwilliam.

Balston had two motives in making his bequest. One was to see *Mark Gertler properly represented in a public collection. He had supported Gertler in the 1920s and 30s and organised the first retrospective of the artist's work at the Whitechapel Art Gallery in 1949. The second motive, expressed in his will, was 'to show what a fairly sensitive collector of limited means could acquire in the period between

Fig 3
Thomas Balston, Mark Gertler, 1931

the two World Wars.' Balston was himself a painter and a patron, and had presented a large group of prints, including work by Robert Gibbings, Eric Gill and Gertrude Hermes, to the Museum in the 1950s. His bequest increased this holding, with the entire work of the wood engraver George Mackley, some twenty-six works on paper by William Nicholson, Albert Rutherston, Ginner and others, four Gertlers and *Stanley Spencer's *Cows at Cookham.*

At about the same time, and in much the same spirit, R.A.P. Bevan (1901–74) presented a group of paintings, drawings and prints by members of the Camden Town Group. Bobby Bevan was the son of the painters *Robert Bevan and Stanislawa de Karlowska. He had come up to Oxford in 1919 and shared rooms in Christ Church with Philip Hendy who remembered paintings by *Spencer Gore and others on their walls. Philip, later Sir Philip Hendy, became Director of Leeds City Art Galleries, where he instituted a series of contemporary exhibitions, and later of the National Gallery. On graduating, Bobby Bevan entered the advertising agency S.H. Benson, of which he became Chairman in 1952. Bevan, who was the inspiration for Ingleby in Dorothy L. Sayers's detective story *Murder Must Advertise,* was also a most effective chairman of the Batte-Laye Trust for the Minories Gallery in Colchester in the late 1950s and 60s, and Vice-President of the Friends of the Ashmolean on its foundation in 1969. He chose the Ashmolean for his gift because of its 'great tradition as far as drawings and prints are concerned,' and because 'pictures exhibited in the Ashmolean would be seen by members of my old University'. In 1957 he gave nine paintings, drawings and prints by members of the Camden Town Group, and twenty-seven of his father's sketchbooks. There were later additions, and Bevan established a fund for the purchase of further works, largely drawings.

No great benefactions of paintings came into the collections in the 1960s and 70s, and its contemporary edge was lost, to the extent that in that

period it was considered not to be in the tradition of the Ashmolean to acquire the work of living artists. Then, within a year of each other, came two further important bequests. The first was presented in 1985 by Beryl Bjelke and Stella Saludes, the sisters of Christopher Hewett (1938–83), in his memory. The Hewett Collection broke new ground in its catholicity of medium and international content, being particularly strong in works by post-war French artists. Born in London, Hewett was educated at Bishop's Stortford College, Hertfordshire, where he was taught modern languages by the poet and champion of contemporary sculpture Walter Strachan. Strachan became a life-long friend, introducing Hewett while still a schoolboy to Sir Sydney Cockerell, and later to many of the leading artists in Paris. After national service Hewett enrolled in 1958 at the Ruskin School of Drawing, Oxford, and went on to the Royal College of Art (1960–63). For two years, from 1964 to 1966 he worked for the architect Roger Saubot in Paris. In 1974 he opened the Taranman Gallery on Brompton Road, London – Taranman translates from the Tuareg as 'that which pleases the eye', or 'the soul'. Early exhibitions devoted to Alphonse Legros and F. L. Griggs gave way to the immediately contemporary, characterised by sculpture by pupils of Henry Moore – Kenneth Armitage, Geoffrey Clarke and Bernard Meadows among them – and introduced the work of a number of French artists such as Nicolas de Staël, *Charles Marq, Geneviève Asse and Brigitte Simon. All were accompanied by catalogues which became famous for the perfection of their production.

Molly Freeman (1895–1986), born Laura Mary Dudley Short, was an artist and teacher. She was herself taught by Professor Alan Seaby at Reading University, and by Noel Rooke and Claude Flight at the Central School. Freeman worked with Hilary Pepler at the St Dominic Press, Ditchling, in the late 1920s and 30s, and, teaching in Cambridge, she met the innovative educationalist Marion Richardson who fostered in her an understanding of art as

therapy. She married Percy Freeman, and they moved to Oxford where Paul Nash, a close friend, was eking out the war. At the end of the war they moved to Harwell, where they remained for the rest of their lives. A series of letters to *The Times* in 1959 on the subject of British philistinism was follwed up by Freeman with a gift of £1000 to the Tate Gallery. This was used to launch the Friends of the Tate Gallery. Her bequest to the Ashmolean in 1986 included works by *Ivon Hitchens, *Ben Nicholson, Paul Nash and Keith Vaughan, and the substantial sum of £64,659.66, for the promotion of twentieth century art, of which this publication is a beneficiary.

Last but not least, mention should be made of the generosity of the Contemporary Art Society. The Ashmolean has been the beneficiary of a number of works. Among the paintings is Gilbert Spencer's *Cottage Garden*, purchased through the Contemporary Art Society in 1939, the year it was painted; Jacques–Emile Blanche's portrait of Max Beerbohm, an oil sketch by *Etchells, a Sickert and three Norman Garstins. Through curatorial necessity, the Museum's later choice of gifts from the Contemporary Art Society restricted itself to works on paper, including two David Jones drawings, and works by Frances Hodgkins, Henry Moore and, more daringly, Bill Jacklin, Frank Stella and Leon Kossoff.

Exhibitions at the Ashmolean have been catalysts to the acquisition of contemporary works. One of the earliest exhibitions held in the museum was a memorial to Ruskin Master *Sydney Carline, and led to the presentation of *Over the hills of Kurdistan*. It is worth remembering in passing that until 1976 the Ruskin School of Drawing was itself housed in the Ashmolean, and so the making and practice of art was not, then, separated from the historic collections. The Second World War was, in Oxford as elsewhere, a further catalyst, and for a decade exhibitions had an entirely contemporary emphasis – could anything today be as radical as the exhibition of Harold Cohen's abstract paintings, drawings and sculpture, organised by the Oxford Art Club in

1951? Karl Parker bought Lawrence Gowing's *Portrait of Julia Strachey* for 20 guineas from an exhibition of Modern British Paintings organised by the Contemporary Art Society in 1941, and more recently *Lucian Freud's *Small Naked Portrait* was purchased for unprecedented sums with the assistance of the National Art Collections Fund as a result of the exhibition at the Ashmolean of *Lucian Freud: Works on Paper*, organised by the South Bank Centre in 1988. It was the energising role of exhibitions which was recognised by the young Alistair, now Lord, McAlpine, when in 1973 he presented to the Museum a prefabricated exhibition gallery specifically to exhibit contemporary art.

The strengths of the Ashmolean's collections as a whole have also acted as a magnet for new acquisitions, sometimes in unexpected ways. The presentation of *John Nash's *Gloucestershire Landscape* came about as the result of an Open University student listening to a tape of the Ashmolean's then director, Sir David Piper, discussing the work of Piero di Cosimo. The student, Patricia Fenn, worked at the time for David Wolfers, Nash's artistic executor and owner of the New Grafton Galleries, and she suggested to Wolfers that the painting be given to the Ashmolean. It was the Museum's outstanding collection of twentieth century wood engravings (Mitchell Gift, 1964) which led Garth Underwood to present a representative group of prints by his father, *Leon Underwood, followed in 1996 by a painting, some drawings and sculpture. The existence of the Talbot Collection of Russian topographical works and the Braikevitch Collection of theatrical designs by Bakst and others for Diaghilev's Russian Ballet undoubtedly strengthened the Museum's case to the Treasury for the allocation of *Kandinsky's *Murnau–Staffelsee I* under the acceptance-in-lieu scheme in 1996.

When the new gallery for twentieth century art opens it is hoped that the generosity of the past will be emulated by a new generation of benefactors to take the Museum into the twenty first century.

Measurements given in the entries that follow are in millimetres, height before width

11

1 **Pablo Picasso** 1881–1974
Blue Roofs, Paris 1901
Oil on millboard, 400 × 600
Bequeathed by Frank Hindley Smith, 1939
1940.1.6; A634

Picasso, whose precocious talent and maturity were remarked upon by contemporaries, was the giant of the modernist movement, a chameleon continually reinventing himself and his art. From the outset he was a name to be reckoned with. He was born of Andalucian parents in Málaga, and made his earliest paintings in La Coruña where his father taught at the local art school. *Blue Roofs, Paris* marks his coming of age, symbolized by the well known signature. From now on he signed himself 'Picasso', abandoning from his signature his father's less characterful name, Ruiz.

Blue Roofs, Paris may be very precisely located, and dated to the artist's second visit to Paris in 1901. He had arrived in May, and stayed at 130 Boulevard de Clichy. He worked through the following month to produce sixty four paintings and numerous drawings for an exhibition at the Galerie Vollard which opened on 25 June.

The lightness and clarity of the limited palette of blue, yellow and white, which the nineteen year old painter commands with such mastery, speaks of the excitement of waking up on early summer mornings in Paris. The shadows of the slate tiles and those cast by the chimney stacks show a distinct authority in the bold way they are marked, rather than tentatively dabbed or stroked. *Blue Roofs, Paris* is a precursor of what became known as Picasso's 'Blue Period', where more sombre tones were achieved by the addition of black to the palette. It has been suggested that this change was a response to the suicide of the painter's close friend, the poet Casagemas, in Paris in February 1901. In those first weeks, however, the joy of being in Paris with an exhibition pending is very evident in this picture.

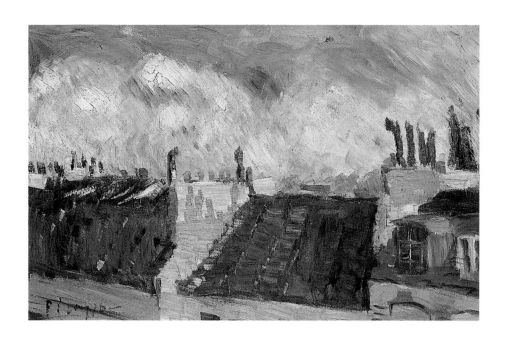

2 **Pierre Bonnard** 1867–1947
*Interior with nude figure c.*1905
Oil on canvas, 540 × 355
Bequeathed by Frank Hindley Smith, 1939
1940.1.9; A627

When Paul Sérusier established the Nabis – the Pro-
phets – from a côterie of artists at the Académie Julien in
1888, Bonnard, Vuillard, Denis and Roussel were al-
ready friends. They took their inspiration from Gau-
guin's symbolism and became actively engaged in the
literary and musical avant-garde in Paris at the end of
the century.
 Bonnard began painting nudes in the late 1890s
and from then on it was a recurrent theme. The fluid
paint with which the artist brushed immediately onto
the canvas replaced an earlier technique of dry patch-
worked colour. The cool, limpid tones in this painting
are not characteristic of Bonnard and suggest a trans-
itional stage between the uncompromising colour of the
Nabis and Bonnard's mature work as a colourist. Transi-
tion is evident too in the mood of the picture, a sense of
hesitancy and underlying anxiety prevailing. The
model's pose, her weight being swung on swivelled hips
and taken on her right foot, recalls the *contrapposto* of
classical sculpture. A postcard of a comparable truncat-
ed Venus appeared among others on the artist's studio
wall, when photographed by Henri Cartier-Bresson in
1945.
 Bonnard's influence on English artists was con-
siderable. Nude subjects such as this influenced Camden
Town artists and the Bloomsbury Group, the former
having affinities in subject matter, the latter in technique
and palette. Bonnard's election as an Honorary Royal
Academician in 1940 was a reflection of the esteem in
which he was held in England.

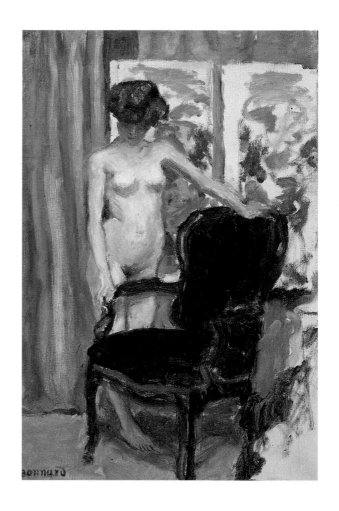

3 **Marie Laurencin** 1883–1956
 *The Artist's Mother c.*1906
 Oil on canvas, 416 × 333
 Purchased with the assistance of the Friends of
 the Ashmolean, 1978.64; A1098

Laurencin trained first as a porcelain painter and from 1902 to 1903 was taught by the flower painter Madeleine Lemaire. However in the subsequent few years, despite her parents' misgivings, she began to establish herself as an independent artist. At first her scope was limited by her circumstances, and her work was largely self portraits and studies using her mother as a model. Then in 1907 Laurencin met *Picasso and was introduced by him to Apollinaire. She and Apollinaire formed a six-year liaison, immortalised in the double portrait *The Muse inspiring the Poet* by Le Douanier Rousseau (1908–9, versions Moscow, Pushkin Museum, and Basle, Öffentliche Kunstsammlung). Under the poet's influence Laurencin rapidly developed a decorative and entirely individual style inspired by the harlequins and pierrots of the *Commedia dell'Arte*. Characterised by white faces, black eyes, patches of bright pure pastel colours and oriental overtones it was a style from which she never deviated in a long working life.

 She had, by her own account, a close and frightening relationship with her mother, which continued until the latter's death in 1913. On a drawing of 1903 (private collection, Paris) she had written 'Despair and die', and much later the artist spoke of the anguish in her mother's eyes. Pauline-Mélanie Laurencin had been widowed in 1905 and about this time the artist produced a series of drawings of her in which she wears widow's weeds in the prevailing fashion of wasp waist and high collar and shoulders. In this painting this has been simplified, though brush marks at the sitter's right shoulder suggest that Laurencin hesitated over the stark simplicity that resulted. The sitter was about 45 at the time but she is presented as less stoutly middle-aged than the drawings of her would suggest. In the implacable stare with which she gazes out one may discern a timeless fusing of matriarchal dominance and self portraiture.

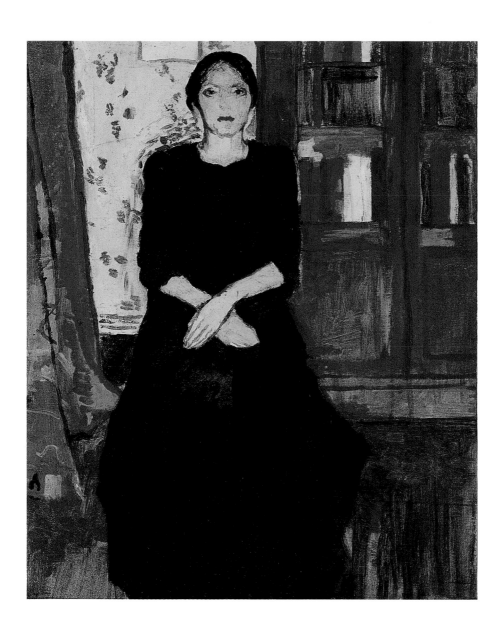

4 **John Singer Sargent RA** 1856–1925
*Steps of the Church of SS Domenico e Sisto,
Rome* 1906
Oil on canvas, 550 × 710
Presented by the artist's sisters, Mrs Ormond
and Miss Emily Sargent, 1929.7; A395

Born in Florence of American expatriate parents, Sargent travelled Europe as a boy, and studied in Paris under Carolus-Duran. He exhibited regularly at the Salon from 1877 to 1884, when his portrait of Mme Gautreau, exhibited as *Madame X*, caused a scandal. While the furore was in flood, Sargent travelled to England to take up an appointment to paint the daughters of a Sheffield steel magnate, Col. Thomas Vickers, whom he had previously met in Paris. He settled in Britain, becoming in 1897 only the second American to be elected to the Royal Academy.

Sargent became the most celebrated and sought-after portrait painter of his day, 'the Van Dyck of our times,' as Rodin put it. It is difficult to understand now what it was that people found so shocking about *Mme Gautreau* (1884, Metropolitan Museum of Art, New York) or *The Misses Vickers* (1884, Sheffield City Art Galleries), but the *décolletage* of the former and the unsettling composition of the latter were considered revolutionary in 1884. Sargent's reputation was made on his bravura portraits, which never failed to glamorize his sitters.

From his new base in London, Sargent travelled on the continent and to the United States, painting portraits and landscapes. A major commission of 1890 was to paint murals for the Boston Public Library, for which he employed *Bomberg as a model. Like so many artists who made good livings out of portraiture, however, Sargent wearied of its bread-and-butter necessity, preferring to paint architectural subjects and landscapes. After a visit to Rome he wrote in 1907: 'I did in Rome a study of a magnificent curved staircase and balustrade, leading to a grand façade that would reduce a millionaire to a worm – it would be delightful to paint a rather anxious, overdressed, middle-aged lady there, with all her pearls and her bat look, and of course never to be chosen to do portraits any more.' In fact Sargent did use the steps as a setting the following year for a portrait of Charles W. Eliot, President of Harvard University (Harvard University Art Collection). The great flight of baroque steps, with its complex perspectives and oblique viewpoint, calls to mind the architectural effects created by Veronese and Tintoretto.

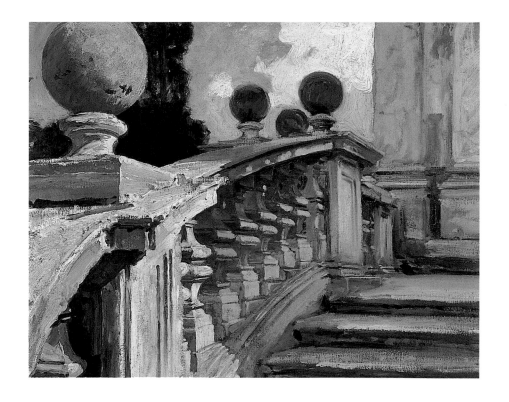

5 **Wassily Kandinsky** 1866–1944
 Murnau–Staffelsee I 1908
 Oil on paper laid on board, 338 × 445
 Accepted by HM Government from the estate of
 Sir Antony Hornby and allocated to the Ash-
 molean Museum, 1997.33; A1207

Kandinsky, who has been described as 'the father of abstraction', was born in Moscow, where he studied law before turning to painting. He went to Munich in 1896 to study under Anton Azbé and Franz von Stück, and remained there until he returned to Moscow in 1914.

In Munich Kandinsky worked with members of the Jugendstil in response to Art Nouveau and Symbolism. In the years leading up to 1914 he was at the centre of new radical groupings of artists, exhibiting first with the Neue Künstler Vereinigung, and later, between 1911 and 1914, as a leader of *Der Blaue Reiter*. In 1910/11 he published *Concerning the Spiritual in Art*, a treatise which provided a metaphysical basis for expressionism and abstraction. From 1922 he taught at the Bauhaus at Weimar, where he published the influential treatise *Point and Line to Plane* (1926). When the school was forced to close in 1933, he moved to Paris where he lived and worked for the rest of his life.

Murnau–Staffelsee I was one of a series of landscapes inspired by the Staffelsee and its surrounding mountains north west of Murnau, seen from the house Kandinsky built with the painter Gabrielle Münther. Some of these paintings were exhibited in 1909 at the Allied Artists' Association in London, where they caused a storm. Frank Rutter defended the artist, and *Augustus John and others were immediately impressed. Kandinsky appears to have left the paintings at Murnau when he left Münther to return to Russia in 1914.

Murnau–Staffelsee I is an important transitional work coming between the artist's symbolist period and his full-blown abstraction. It is a lyrical expression of last light as the final gleams of day reflect on the lake, and the lights of houses on the shadowed mountainside spring up. Painted in wonderfully fluid brushstrokes, it uses the range of colours so characteristic of his later work, hot pinks, crimsons and electric blues and yellows. It is comparable to the work of Edvard Munch, Emile Nolde, and to the transcendental landscapes of Ferdinand Hödler, and is contemporary with the dune landscapes of Piet Mondrian. Kandinsky described art as horseshoe-shaped, the two extremities, abstraction and intense poetic naturalism, being close partners.

20

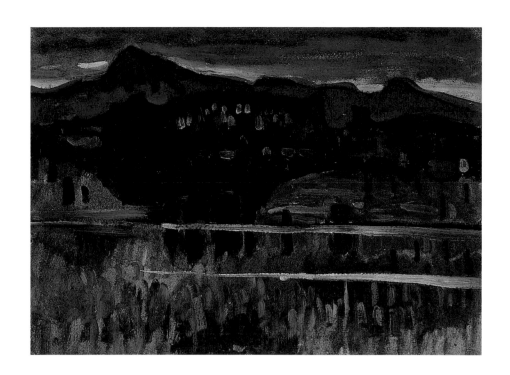

6 **C.R.W. Nevinson** 1889–1946
The Towpath 1912
Oil on canvas, 765 × 560
Bequeathed by Mrs W. F. R. Weldon, 1937
1937.80; A499

From a distance of 85 years this painting has a sentimental air, fostered by its limpid pinks and blues, its subject matter and the intense romanticism of the urban scene. In 1912, however, it was the essence of 'low life', the genre which looked to urban life and industrialization for inspiration.

In *The Towpath*, Nevinson is on the verge of radical change, but has not yet broken with the traditional narrative element in English painting. Who are the lovers – is he a bargee, a coalman, an inhabitant of the tenements? And she? Are they lovers, or is he pushing her towards the brink? They must have come from a place of work, for both to be in shirt sleeves raises questions in an age when even the poorest went with jacket buttoned up.

Nevinson had seen a painting of Venice by Signac which made a great impression on him at the Venice Biennale of 1907. *The Towpath* is an exact topographical record of the Regent's Canal as it enters the Maida Hill Tunnel at Marylebone, with the power station on the left and the westernmost block of the Wharncliffe Gardens Estate on the right. Although he has omitted one of the two chimneys, the artist has dwelt on the industrial detail, and on the curious cabin and ladder which were still there in 1987.

In March 1912 Nevinson saw the Italian Futurist Painters exhibition at the Sackville Gallery. He was already sympathetic to modern urban subjects as *The Towpath* illustrates, but was captivated by Futurism, and after the second Post Impressionist exhibition in 1912 he finally abandoned soft-hued pointillism for the harsh geometry of English Futurism and Vorticism.

The First World War was something of an inspiration to Nevinson, and like Paul Nash he produced some of the great and enduring images of the conflict. After a brief post-war response to New York's 'Gotham City' qualities, Nevinson lapsed into easy and immensely popular landscapes of the south of England. Never again did he achieve his wartime intensity of vision, and on the outbreak of the Second World War he had a nervous breakdown and never recovered.

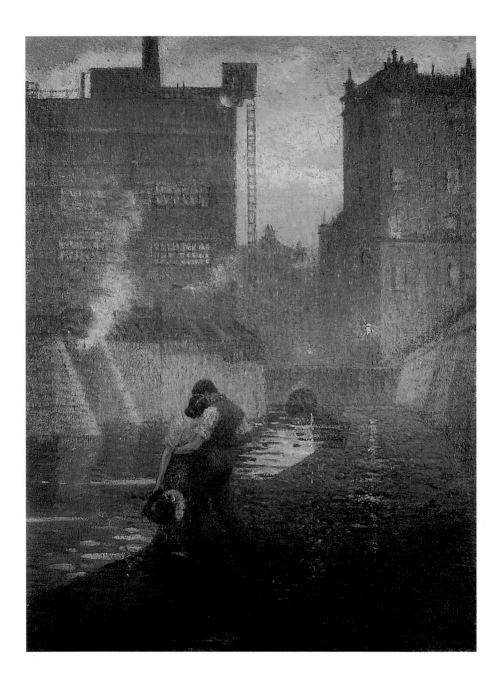

7 Frederick Etchells 1886–1976
*On the Grass c.*1911
Oil on panel, 360 × 510
Presented by the Contemporary Art Society,
1946.376; A730a

Born in Newcastle-upon-Tyne, Etchells attended the
Royal College of Art from 1908 to 1911. Thereafter he
went to Paris and met *Picasso, *Braque and Modigliani.
He was at the forefront of the avant garde in the years
leading up to the outbreak of the First World War, and
was briefly at the heart of the Bloomsbury Group. He
became Duncan Grant's closest painting companion
and was an active member of Roger Fry's Omega Work-
shops. Etchells left the Omega Workshops in 1913 after
a split which led to the founding with Wyndham Lewis
of the Rebel Art Centre. Etchells became a founder
member, and a contributor to *Blast*, the manifesto of the
Vorticists. This influential group included Lewis, *Wil-
liam Roberts, Gaudier Brzeska and Edward Wadsworth.
In 1920 Etchells joined Group X, a short-lived grouping
which exhibited at the Mansard Gallery in a bid to cre-
ate an alternative to the Royal Academy and New Eng-
lish Art Club exhibitions.

Etchells gave up painting in the early 1920s and
became an architect. He translated Le Corbusier's
Towards a New Architecture into English (1927) and
designed one of the first modernist buildings in London,
for the Crawford Advertising Agency in Holborn (1930).
For a short time in the 1920s he became with Hugh
McDonald a publisher of limited edition books, commis-
sioning *John Nash's *Poisonous Plants* (1927). His sec-
ond wife, whom he married in 1932, was the wood
engraver Hester Sainsbury.

On the Grass, described by the artist as a sketch,
was first owned by Lady Ottoline Morrell's brother,
Lord Henry Bentinck. Ottoline Bentinck had married
Phillip Morrell, and it was at the Morrell's house in Bed-
ford Square in 1910, in the company of Roger Fry, D.S.
MacColl and Sir Charles Holmes, that the Contempor-
ary Art Society for promoting modern art and living
artists was born.

First exhibited at Fry's second Post-Impressionist
exhibition in 1912/13, *On the Grass* shows Etchell's sis-
ter, the painter Jessie Etchells, and a friend in the garden
of a house in West Horsley, Surrey, walking distance
from Durbins, the house that Roger Fry had designed
for himself in 1910. In its clear-toned palette and tech-
nique of separate colour brushstrokes, it is a deceptive-
ly simple and very advanced piece of work for its time.

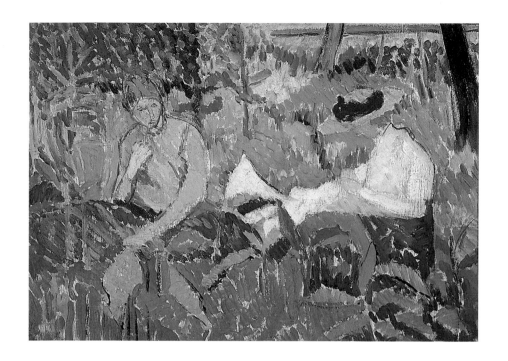

8 Spencer Frederick Gore 1878–1914
The Cinder Path 1912
Oil on canvas, 356 × 405
Presented by R. A. P. Bevan, 1957
1957.18.1; A903

Gore was regarded by contemporaries as a leader of the avant garde before the First World War. He was a founder member of both the London Group and the Camden Town Group, and was active in the Allied Artists' Association. In 1912 he organised the decoration, by *Gilman, Epstein, Gill and Wyndham Lewis, of 'The Cave of the Golden Calf', Mme Strindberg's cabaret theatre club, considered outrageous at the time, in a basement in Heddon Street.

The Cinder Path is one of three versions Gore painted of the subject – another is in the Tate Gallery – and is a direct and immediate response to the hot, pure colours of Gauguin, the Nabis and the Fauves, whose work Gore had seen at the first Post-Impressionist exhibition. Gore was the only member of Sickert's circle to be included by Roger Fry in his second Post-Impressionist exhibition, where he exhibited a painting of this title, perhaps the version in the Tate. It is likely that the Ashmolean version, smaller and less finished, was executed first, perhaps on the spot. It is a most sophisticated and radical work in technique, colour and content, and was owned by the Polish painter Stanislawa de Karlowska, wife of *Robert Bevan, who herself treated the English landscape to the hot palette of the Fauves.

The Gore family spent August and September 1912 in Harold Gilman's newly built house in Letchworth, the Garden City begun in 1903, which was the embodiment of fashionable ideas about modern living. *The Cinder Path* is a strictly topographical image. It describes the path which linked the old market town of Baldock in Hertfordshire to the end of Works Road, Letchworth. The creep of new housing, red roofs and white stucco, appears on the horizon, while the rustic fence straggling along the left hand side of the picture contrasts with the directness of the cinder path. The path, itself a product of coalfires and urbanization, strikes out without regard for the lie of the old landscape. In its use of reds, considered by the Fauves to be an 'anti-natural' colour, it describes the sultry heat of the season, harvest time.

Gore's attachment to painting in the open air ultimately cost him his life, as he died aged 36, from pneumonia contracted while painting in Richmond Park in the damp March air of 1914.

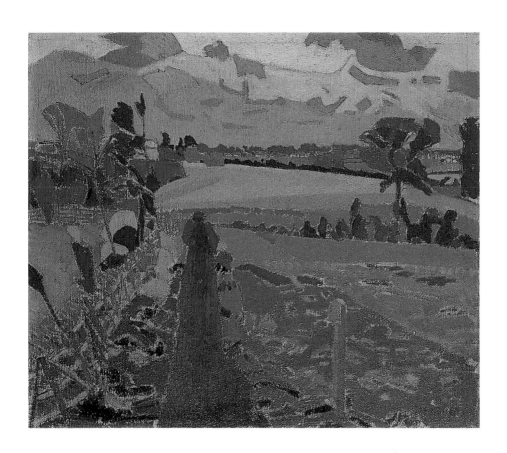

9 **David Bomberg** 1890–1957
Procession 1912–14
Oil on paper, laid on panel, 352 × 758
Presented in memory of the artist by Mr and Mrs
James Newmark, through the Contemporary Art
Society, 1981.604; A1120

Bomberg spent the first five years of his life in Birmingham, before his itinerant Polish Jewish parents settled in Whitechapel. While studying, first under Walter Bayes at the City and Guilds Technical Institute, and later with W.R. Lethaby and *Sickert, he chanced to meet *Sargent at the Victoria and Albert Museum. Sargent invited him to model for the Boston Public Library murals, and encouraged him to go to the Slade School, where his fellow pupils included *Roberts, *Spencer and *Gertler.

Bomberg went to Paris in 1913 with Epstein to select works for the exhibition *A Review of Modern Movements* (1914, Whitechapel Art Gallery). The visit, when he met *Picasso, *Derain and Modigliani, preceded his first precocious show in London at the age of twenty-four in 1914 at the Chenil Gallery. This exhibition, which was visited by Brancusi, Duchamp-Villon and Marinetti, established Bomberg as the leader of the avant garde in Britain, so much so that he has often been mistakenly included among the Vorticists.

The First World War, which catalysed the production of many artists, temporarily froze Bomberg's creativity. He hardly worked at all, and after the war his uncompromising approach failed to find favour with the critics and would-be patrons. There is no precedent for *Procession*, which remained in the artist's studio until his death. A drawing for it exists (London art market, 1998) and probably the painting records a funeral procession, a feature of East End Jewish custom. But its title, shorn of a definite or indefinite article, emphasises the unspecific nature of the urban masses. This was one of the concerns which allied Bomberg temporarily to the Vorticists and, with the minimum representation and the maximum sense of motion, the artist alludes to the dehumanization of the city dweller. Bomberg took to an extreme Roger Fry's dicta about form, writing in his exhibition catalogue 'where I use Naturalistic Form, I have *stripped it of all* irrelevant matter.'

There is early evidence in *Procession* of Bomberg's later fascination with the substance of paint and colour, aspects he came to develop to express mood in landscape and townscape. He passed this legacy to artists he taught years later, among them Frank Auerbach, Leon Kossoff and Dennis Creffield.

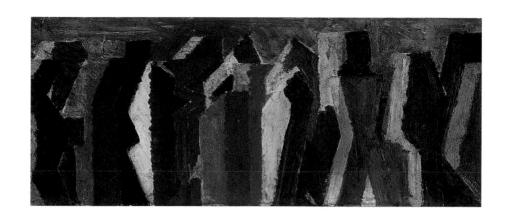

10 John Nash RA 1893–1977
A Gloucestershire Landscape 1914
Oil on canvas, 500 × 600
Presented by the New Grafton Gallery and the
trustees of the John Nash Estate, 1978.67; A1099

Unlike his brother Paul, John Nash had no formal art
training. He exhibited with the London Group, the Cam-
den Town Group, and was invited in 1915 to join
*Gilman, *Ginner and *Bevan in the short-lived Cum-
berland Market Group. Gilman gave Nash practical ad-
vice about pigments, and advised him not to paint from
nature but from drawings done on the spot.

Nash saw active service in the First World War in
the Artists' Rifles, becoming an Official War Artist, and
in the Second as a Royal Marines officer, with responsi-
bilities for camouflage. In 1920 he was in the vanguard
of the revival of wood engraving, but abandoned the
medium in 1934, saying that he could complete three or
four drawings in the time it took him to make a wood
engraving. He taught, under the mastership of *Sydney
Carline, at the Ruskin School of Drawing in Oxford
(1924–29). Subsequently he became an assistant teacher
of design at the Royal College of Art until 1958.

Nash had lived from early childhood in the Chil-
terns in Buckinghamshire, but in 1929 he and his wife
Christine moved to Bottengoms, a remote farmhouse at
Wormingford, Essex. They lived a subsistence existence
but here Nash pursued his passion for gardening and
plants. Nash was a regular contributor to magazines
such as *The Countryman*, and illustrated more than thir-
ty books, notably *Poisonous Plants* (1927), commis-
sioned by *Frederick Etchells. He became a Royal
Academician in 1951.

Profoundly elegiac, *A Gloucestershire Landscape*
is an example of a peculiarly English phenomenon
which has characterized so much art and literature in
this country in the twentieth century, the nostalgic re-
cording of the passing of a way of life. The work of writ-
ers such as Richard Jeffries and T.H. White marked the
change, as did painters such as Edward Bawden and
*Stanley Spencer, and engravers, photographers and
film-makers, many of whom were Nash's friends.

Typical of Nash's landscapes, always, as he put it,
'searching for the basic forms of things', this is a deser-
ted scene – the harvesters have gone home, the cumulus
clouds have moved in, and the painting has the ominous
brooding silence and black light that foreshadows a late
summer storm. As such it is an enduring image of Eng-
land in August 1914.

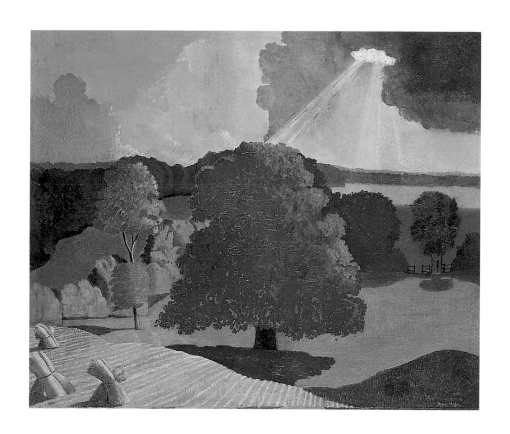

11 **Mark Gertler** 1884–1955
 Gilbert Cannan and his Mill 1916
 Oil on canvas, 990 × 710
 Bequeathed by Thomas Balston through the
 National Art Collections Fund, 1968.24; A1041

Brought up in poverty in the Jewish immigrant commu-
nity in the East End of London, Gertler was apprenticed
to the stained glass manufacturers Clayton and Bell.
With the encouragement of William Rothenstein and the
support of the Jewish Aid Society he attended the Slade
School after winning a scholarship at the age of 16. At
the Slade he met *Nevinson and Dora Carrington, with
whom he maintained a liaison until in 1917 she left him
for Lytton Strachey. His first patron, Edward Marsh,
introduced Gertler to English literary society, principal-
ly through the Morrells at Garsington Manor, near
Oxford. Gertler was welcomed at Garsington for
months at a time for his beauty and elegance of dress,
his fund of stories and his ability to entertain.

In 1914 Gertler went to stay with the writer Gil-
bert Cannan (1884–1955) and his wife Mary, in a con-
verted windmill at Cholesbury, Hertfordshire. He be-
came a regular visitor over the following two years,
joining parties which included John Middleton Murry,
Katherine Mansfield, and Frieda and D.H. Lawrence.
Later Gertler introduced Cannan to the music hall life of
the East End immigrant community. Cannan's novel
Mendel (1916) reflected these encounters, while Law-
rence himself drew on Gertler for the character of
Loerke in *Women in Love*.

This painting, first exhibited in 1916 with the Lon-
don Group at the New English Art Club as 'The Wind-
mill', marks the transition in Gertler's life from the East
End to metropolitan sophistication. It is, with *Merry-go-
Round* (1916, Tate Gallery), Gertler's most radical pic-
ture. It took him two years to paint, and had entailed
many studies from nature, particularly of the chestnut
tree. It owes something to *Window at Vers* by *Derain,
exhibited in the second Post-Impressionist exhibition in
1912, and also to 15th c. Italian painting, in particular
Uccello's *Rout of San Romano*. Most remarkable, how-
ever, are its expressionist qualities, comparable to paint-
ings and prints by Kirchner, Schmidt-Rottluff and
others. The large black and white dog, Porthos, had
been Barrie's model for 'Nana' in *Peter Pan*. Gertler's
health was chequered by attacks of manic depression,
tuberculosis and spells in sanatoria. Beset by financial
anxieties and the onset of the Second World War, he
committed suicide in 1939.

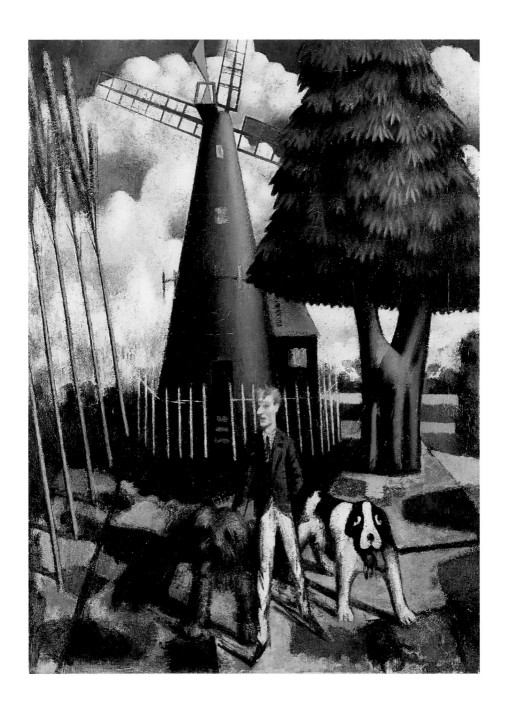

12 Harold Gilman 1876–1919
Interior with Mrs Mounter 1916/17
Oil on canvas, 510 × 760
Presented by Brian Fairfax Hall in memory of
Edward Le Bas, 1968.20; A1037

Gilman studied at the Slade from 1897 to 1901 under
Wilson Steer in a group which included *Augustus John
and William Orpen. He spent a year in Madrid (1902–03)
copying Velazquez, as did *Glyn Philpot, and studied
seventeenth century Dutch painting in London. In 1911
he went to Paris with *Charles Ginner and Frank Rutter,
where he saw a roomful of Van Goghs at Bertheim's
gallery. He was, like *Bomberg, bedevilled by poverty,
but unlike Bomberg he was a joiner of groups – he was
a founder member of the Fitzroy Street Group in 1907,
and the Allied Artists' Association the following year.
Successively he was a founder member of the Camden
Town Group (1911), and president of the then radical
London Group (1913).

In 1913 Gilman established an alliance with Gin-
ner as a 'Neo-Realist' in an exhibition at the Goupil Gal-
lery, and after meeting *Sickert, shared Sickert's subject
matter of peopled interiors, nudes on beds and his
painterly technique and method of squaring up draw-
ings.

He began to exhibit portraits of Mrs Mounter in
November 1916 at the London Group. A study for the
paintings in the Walker Art Gallery, Liverpool, and the
Tate Gallery, is also in the Ashmolean. Mrs Mounter was
Gilman's landlady in Maple Street, in the years between
the failure of his first marriage, and his second to the
painter Sylvia Hardy in 1917. Seen as a typical Camden
Town Group everyday subject, one described by critics
as 'shabby genteel', it was denigrated by Clive Bell, with
its 'tendency to concentrate on a mediocre and rather
middle class ideal of honesty . . . [as being] typically
British.' Another Ashmolean drawing, dated 1918, gives
Mrs Mounter a careworn, almost desperate look, but in
the oil she appears to have a greater sense of resilience,
as she looks directly at the spectator, tough, humorous
and not bowed.

The alarmingly hot colours, derived from Van
Gogh, intensify a sense of loneliness and melancholy
that has been interpreted as the artist's response to the
conditions of the home front in the middle of the First
World War. The colours, notably the orange of Baltic
pine red lead and green primer of the unpainted wood
work, are not so wildly removed from reality. Gilman
died in the Spanish influenza epidemic of 1919.

34

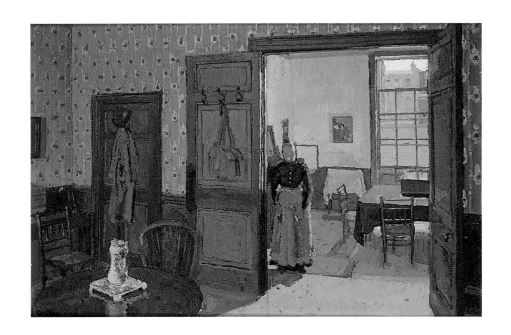

13 Walter Richard Sickert RA 1860–1942

Ennui 1917–18
Oil on canvas, 767 × 563
Bequeathed by Frank Hindley Smith, 1939
1940.1.47; A618a

Painted at 15 Fitzroy Street, London W1, towards the end of the First World War, this version of *Ennui* is the latest of five, the first begun in 1913–14. The series belongs to a body of work which may be seen as Sickert's reaction to modernism, and which won him Virginia Woolf's admiration as 'a novelist in paint'. For subject and mood this group harks back to late nineteenth century narrative painting, while exhibiting technical and stylistic affinities with Post-Impressionism. The flickering patterns built up from independent brush strokes in the wallpaper and tablecloth recall Vuillard's fascination with pattern on pattern.

The strength of the painting derives from its creation of a sense of intrusion. The relationship between the figures is an enigmatic one: husband and wife? father and daughter? But the problem is the same, that of spent men and their relationship with women. The poet W.H. Davies, in his autobiography *Later Days* (1925), remembered the image as the man having his arm around the woman's waist, so strong is the feeling of shackled detachment.

There are a number of other equally enigmatic sub-plots as both characters ruminate or regret. The gorgeous humming birds billing and cooing, but trapped by the taxidermist's art under a glass dome; the pictures on the walls, oleographs perhaps of some diva of the music hall – the detail is significant, having a melodrama about it that is missing in the room itself. One of the many carefully considered studies (Ashmolean Museum) has a refrain inscribed on it from a music hall song by Herbert Cole, 'Oh! I say!', written for the male impersonator Nellie Power. The man in the painting, known as 'Hubby', was a down-and-out school acquaintance of Sickert's, to whom the artist gave shelter and kept in beer over a number of years.

In the alert eyes of the man there may be a progression from those of earlier versions in which they are sunk in reverie, to a feeling of hope. This is echoed by the patterns of wallpaper and tablecloth which reduces the bleakness of the earlier versions. This element of optimism may reflect the ending of the war. The nuances of the painting are multifarious, and bear out Sickert's statement, 'If the subject of a picture could be stated in words there had been no need to paint it.'

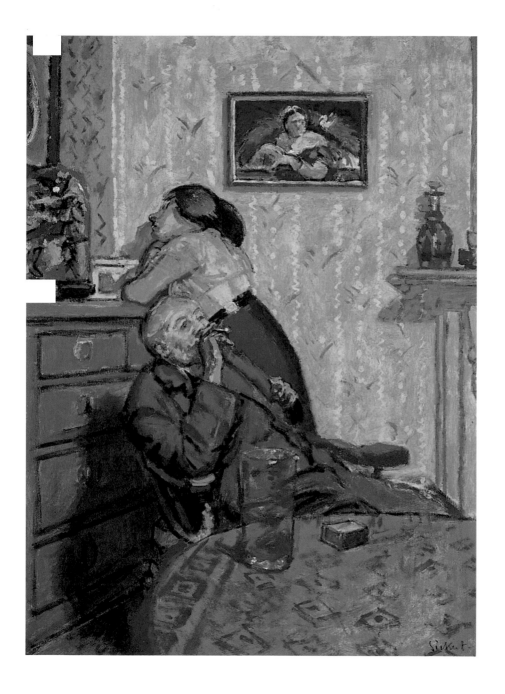

14 Sydney Carline 1888–1929

Over the Hills of Kurdistan: flying above Kirkuk
1919
Oil on canvas, 380 × 450
Presented by the artist's widow, Gwendolyn Harter, 1929.30; A398

Sydney Carline paid his way through the Slade School from 1908 to 1911 by drawing illustrations for Oxford journals and making portrait medallions. At the Slade he made friends with *Gertler, *Nevinson and *Stanley Spencer, and after the war became Spencer's brother-in-law. Sydney and his brother Richard attended Tudor-Hart's atelier in Paris in 1914, and there they encountered the work of the Fauves, the Cubists, and *Kandinsky, and attended Gertrude Stein's receptions.

When war broke out Sydney and Richard joined the Royal Flying Corps on the Western Front, flying Maurice Farman biplanes. In one of these he was shot down over the Somme. Later, on the Italian Front, he flew Sopwith Camels. Transferred to the Department of Camouflage, the Carlines were sent to the Middle East to record the war against the Turks. The impact of their experiences had a catalytic effect on their art comparable to the experiences of *Nevinson.

Their output was prolific and fuelled a series of exhibitions first at the Goupil Gallery (1920), and subsequently at Manchester City Art Gallery and Zwemmer Gallery (1921). In 1922 Sydney was appointed the Ruskin Master of Drawing in the University of Oxford, a post he held until his death. When Master he invited *John Nash and Gilbert Spencer to teach, and Paul Nash and Stanley Spencer came also as visiting teachers.

Carline employs colours inspired by the Fauves to record a specific historic event in a particular location. A study (Imperial War Museum) of a Bristol fighter plane returning to Mosul from a punitive expedition over central Kurdistan is dated 23 July 1919. It records the disorientation of traditional perspective in painting from the air. What it does not reveal are the frost-bitten hands and frozen paint which were a hazard of these missions. In this and associated paintings Carline records a phenomenon which becomes apparent only with hindsight, the association of the artist with the angel of death, and the distancing of the engine of death from its victims, a terrible feature of airborne war. Carline's work, however, transcends the particular, and inspired by the moment reaches a pitch of acuity to create a series of iconic images.

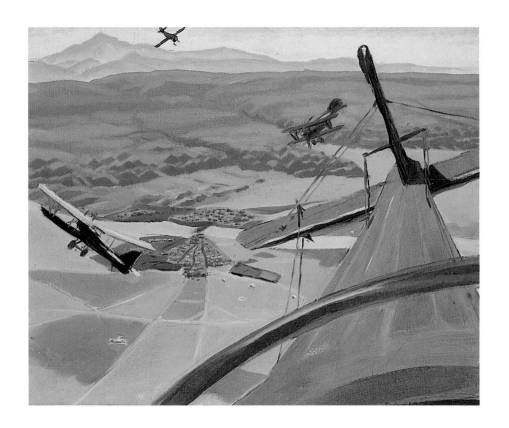

15 Robert Bevan 1865–1925
Showing at Tattersall's 1919–1921
Oil on canvas, 580 × 710
Bevan Gift, 1957.14.3; A898

Robert Bevan's career fell into three distinct phases, each dominated by his love of landscape and horses. He had trained at the Académie Julien in Paris in the late 1880s, and in 1892 spent a year with the Glaswegian painter Joseph Crawhall and the animal illustrator J. D. Armour in Tangiers. There is evidence that his art might have developed along conventional lines, to rival Alfred Munnings as a successful painter of horses and landscape, but for a series of formative encounters.

In 1893–4, staying at the Académie de l'Hôtel Julia at Pont Aven in Brittany, Bevan met Gauguin, Sérusier and the Irish painter Roderic O'Conor. There he became a Post-Impressionist, but he later destroyed most of his work from this period. In 1897 he married the Polish artist Stanislawa de Karlowska. Together they pursued an isolated experimental course of painting in the landscapes of Poland, Sussex and Exmoor. It was the hot colours and curling brushstrokes of a Polish scene, *The Courtyard* (private collection), that brought ridicule from the critics when it was exhibited in 1905. The palette of *Ploughing in the Downs* (1906; Aberdeen Art Gallery), described by W. H. Hudson in *Men, Books and Birds* as 'a rainbow horse drawing a crimson plough, followed by a magenta ploughman over a purple field', caught the attention of *Sickert, *Gilman and *Gore.

When Bevan exhibited with the Allied Artists' Association in 1908 Gore immediately invited him to join the Fitzroy Street Group, which met in Sickert's rooms. The fraternity of like-minded artists had an effect on both Bevan's subject matter and his technique. The subject matter – cab-yards, mews and horse sales of London suggested to him by Sickert – were in keeping with the tenets of the Camden Town Group of which he became a founder member. Bevan's technique developed into an angular style in which colour fused into broad masses of a more subdued and subtle tone.

Bevan exhibited a number of paintings of Tattersall's horse auctions, and this one, now known as *Showing at Tattersall's*, was included in the exhibition 'Peintres Anglais Modernes' at the Galerie Druet in Paris in 1921, and at the artist's memorial exhibition at the Goupil Gallery in 1926, to which *John Nash contributed the catalogue introduction. Its detached, stylised observation of horsecopers and fanciers is an affectionate comment on a then vanishing London.

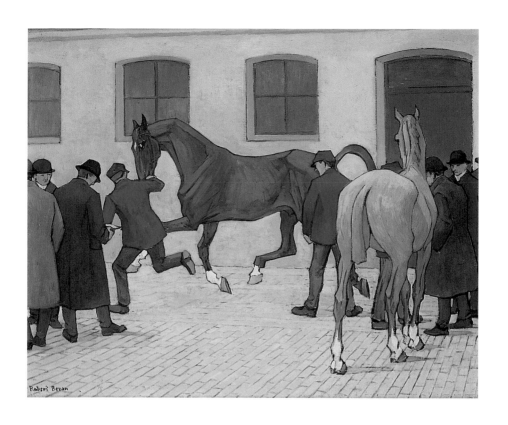

16 **Emile-Othon Friesz** 1879–1949
Les Vosges 1919
Oil on canvas, 640 × 800
Bequeathed by Frank Hindley Smith, 1939
1940.1.7; A625

Like *Braque, Friesz was a native of Le Havre, and stud-
ied there under Lhuilier, who had been a pupil of Corot.
A fellow student and friend was Raoul Dufy. Later in
Paris Friesz joined the Fauves and exhibited with
*Matisse and Braque at the Salon d'Automne. His Fauve
manner attracted the attention of *Spencer Gore in
the first Post-Impressionist exhibition in London in
1910–11, and he was chosen by Roger Fry for the sec-
ond Post-Impressionist exhibition in 1912 for the Cézan-
nesque qualities in his work.

 Friesz was mobilised on the outbreak of war, only
to be invalided out of active service. Like *Carline he was
detailed to the Service Téchnique de l'Aéronautique to
complete a series of studies of aeroplanes (Paris, Musée
des Deux Guerres). On demobilisation in March 1919 he
left Paris and made for the mountains of the Jura and the
Vosges where he painted this picture. Critical acclaim in
the 1920s brought him the major commission for the
murals in the Palais de Chaillot in Paris. He continued to
teach at the Académie de la Grande Chaumière until
1939.

 The First World War arrested the development of
experimental painting, and in the aftermath artists
found themselves taking stock. Whereas *Matisse in the
warm south pursued a softer, less strident manner,
Friesz among cold, dark forest-clad mountains reverted
to a Cézanne-inspired vision, with a cold palette of
swirling internal arcs and arabesques.

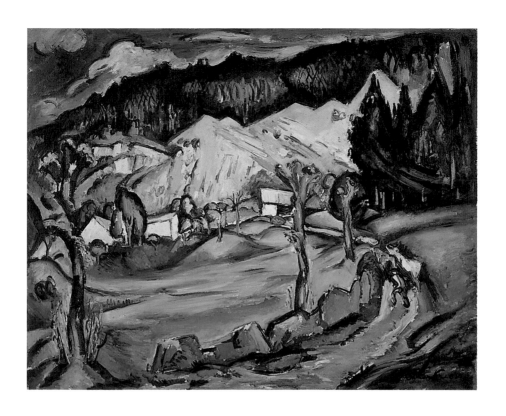

17 Henri Matisse 1869–1954
Nude on a sofa 1919
Oil on canvas, 550 × 330
Bequeathed by Frank Hindley Smith, 1939
1940.1.11; A629

Matisse, with *Picasso, has come to be regarded as one of the giants of the twentieth century. In the first decade he, with *Derain, Vlaminck, Marquet, *Friesz and others developed an aggressive approach to colour to define form and express feeling. This was the short-lived movement known as Fauvism, which had radical and far-reaching consequences for painting throughout the century, and re-emerged in Matisse's designs for Stravinsky's *Le Chant du Rossignol* for Diaghilev's Ballet Russe in 1919.

This painting dates from Matisse's sojourn at Nice in the south of France in 1919. It was a period of reaction to the pre-war aeshetics of Cubism, Futurism and Vorticism, to Matisse's own brand of Fauvism, and a time of reappraisal and reflection. On this visit he took a room in the Hôtel de la Mediterranée et de la Côte d'Azur, on the Promenade des Anglais, and concentrated on a series of spontaneous sketch-like studies of the female form. These were Odalisques in the tradition of Delacroix, Ingres and, most immediately, Renoir. Matisse described the period as 'NICE: work and happiness', and based himself in Nice for the rest of his life.

Matisse's early Nice period is characterized by the abandonment of strong, intense colours and the predominance of pinks, greens and greys, a softening of form and the rediscovery of flesh, a fact remarked on by contemporary critics. Some of these, notably Jean Cocteau, were not impressed. The swirling arabesques in the wallpaper appear in a number of other paintings from this period as does the striped tablecloth, while the cloth-draped sofa of the title appears to be the chaiselongue visible also in other paintings.

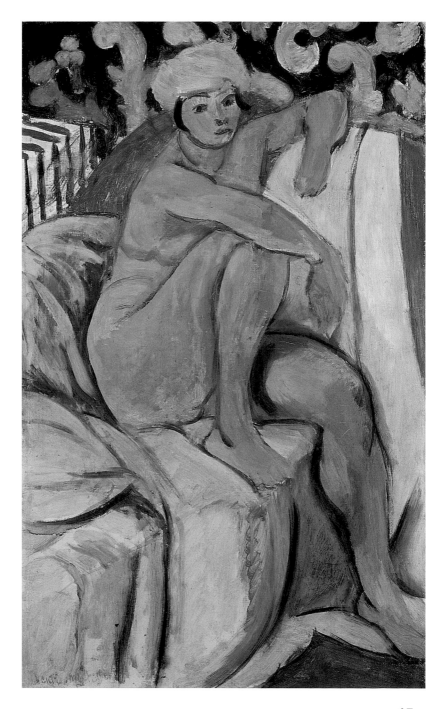

45

18 Leon Underwood 1890–1975
Charles Ashdown 1922
Oil on canvas, 445 × 342
Presented by the artist's son, Garth Underwood,
1996.382; A1201

The Brook Green School of Art, founded in Hammer-
smith by Underwood in 1921, set out to break away from
'the harmful and repressive influences of orthodox art
training'. Underwood had had very little formal educa-
tion, and his own art training, first at the Regent Street
Polytechnic (1907–10) and then at the Royal College of
Art (1910–12), had consisted largely of copying casts
from the antique. On demobilization in 1918 he took the
opportunity provided by official rehabilitation schemes
to attend Henry Tonks's life classes at the Slade School.

Tonks encouraged Underwood to set up his own
school, and directed potential students to him, among
them Eileen Agar, Gertrude Hermes and the Indian
painter-etcher Mukul Dey. He continued to teach part-
time at the Byam Shaw School and the Royal College,
and students, including Blair Hughes-Stanton and Henry
Moore, gravitated to Underwood at Brook Green. His
teaching revolved around life drawing, but broke away
from the traditional day-long poses. Instead Underwood
encouraged his models and pupils to work fast in an
attempt to capture volume, speed and movement.

In 1925 Underwood went to northern Spain to see
the cave paintings of Altamira. This provided him with
the basis for a theory of art which preoccupied him for
most of his life, and took him on a three year journey to
New York and Mexico. By the time of his return at the
end of 1928 his work had changed profoundly, and he
exhibited paintings and sculpture strongly influenced by
his experiences. In 1931 he founded the magazine *The
Island*, funded by Eileen Agar, which ran for four issues
and championed the belief that poetic imagination was
more important than style or method.

The portrait of Charles Ashdown, also known as
Farmworker, Ashurst, was painted during a summer hol-
iday at Ashurst near Tunbridge Wells, Kent, in 1922. It is
an extremely sensitive study of a local farmer, of whom
Underwood also made a drypoint engraving, in prepara-
tion for the nine feet long picture *Peasantry*, exhibited in
1924 at the Pittsburgh International. The portrait belongs
to a tradition of rural and seafaring subjects that had
inspired artists of the Newlyn School, and Henry Lamb
and *Augustus John, in a search for the 'primitive'.
There is no hint in the portrait of the radical change of
direction that Underwood was on the point of making.

46

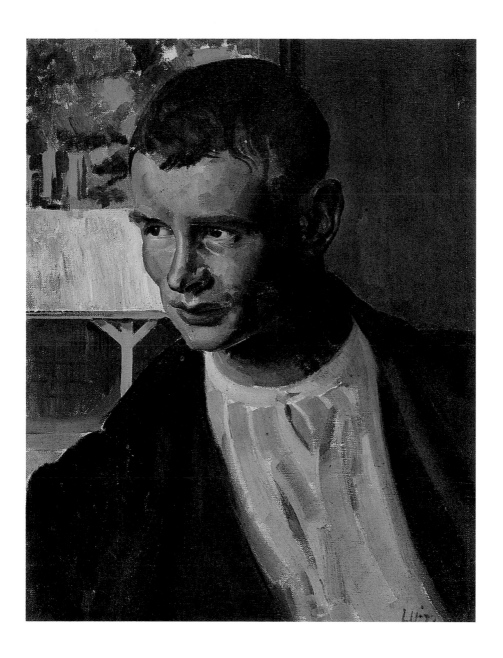

19 Glyn Philpot RA 1884–1937
Italian Soldier 1922
Oil on canvas, 665 × 550
Presented by Francis Howard, 1941.181; A684a

It is for his portraits that Glyn Philpot was and remains best known. His was a precocious, if conservative talent, for even before going to Paris in 1904 his work had been hung in the Royal Academy. When his first solo show opened at the Baillie Gallery in London in 1910, he had arrived, at the age of twenty-six. From then on he was commissioned on both sides of the Atlantic for society and official portraits, such as that of Dr Charles Gore, Bishop of Oxford (1920, formerly Cuddesdon Theological College). In 1913 he won first prize at the Carnegie International Competition in Pittsburgh.

Philpot was elected Royal Academician in 1923, at thirty-eight the youngest of his day, and there he became a much-loved and long-remembered teacher in the Schools. He became a Trustee of the Tate Gallery in 1927, and was invited to show at the Venice Biennale in 1930. On his death in 1937 Philpot was given a retrospective exhibition at the Tate, yet his work rarely appears in standard surveys of twentieth century British painting.

Philpot's early established mature style, with its highly finished treatment, owed much to Philip Connard who had taught him at Lambeth School of Art. It also developed out of the year he spent at the Académie Julien studying Old Masters in the Louvre in 1905, and by successive visits to Spain where Velázquez became an inspiration.

In the 1920s he sat on the jury of the Carnegie International, and this brought him into close contact with American art, something which was rare in his generation. It was this development in his life that gave him the motive power to move from Edwardian aesthete to thirties modernist.

Italian Soldier, painted in Italy in 1922, is one of a series of three Philpot exhibited at the Grosvenor Gallery the following year. Combining the characteristics of portraiture with the anonymity of genre, it may be seen as an early transitional work in the artist's career. Its colouring and foreshortened angle of vision is reminiscent of Titian, Veronese and indeed *Sickert, lit as it is from below as though the subject were on stage. It has the nonchalant casualness identifiable with the mood of a post-war world, and an enigmatic quality common to Philpot's best work, which raises a sense of unease in the viewer and may account for the artist's unsustained reputation.

48

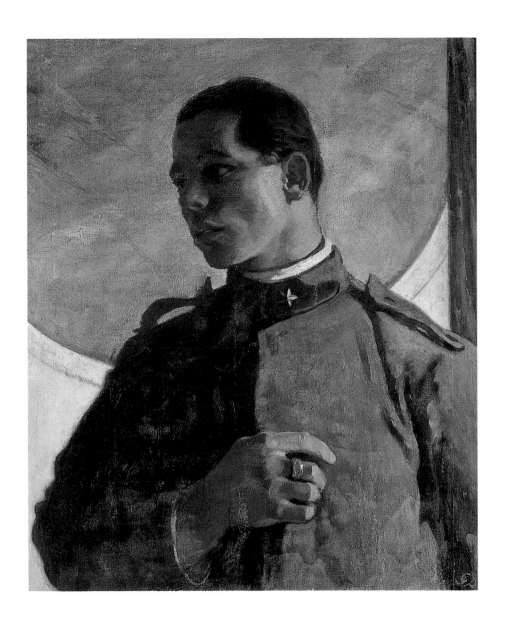

20 William Roberts RA 1895–1980
T. E. Lawrence as Aircraftman Shaw 1923
Oil on canvas, 915 × 610
Presented by Professor A. W. Lawrence, 1946
1946.267; A727

Like *Gertler and *Bomberg, Roberts was born and brought up in the East End of London. At 14 he became an apprentice commercial artist, designing posters for Sir Joseph Causton & Co. Ltd, and attended evening classes at St Martin's School of Art. In 1910 he won an L.C.C. scholarship to the Slade School. Roberts was briefly associated with Roger Fry's Omega Workshop, and then with the Vorticists. He saw active service as gunner, and in 1917 became an Official War Artist. In the early 1920s, Roberts continued to exhibit with the radicals, notably with Group X, but increasingly went his own way. He took a part-time job at the Central School of Arts and Crafts, which he held for 35 years from 1925, with a break in the Second World War when he taught in the Technical School in Oxford. After 1945 he began to exhibit at the Royal Academy regularly, becoming an Academician in 1966.

Over sixty years Roberts evolved an idiosyncratic and immediately recognisable style. His subject matter observed everyday twentieth century urban life, in a mechanistic style of high-keyed colour whose complex compositions, with their structured internal rhythms, have a frieze-like quality and owed something to Léger and Delaunay. Roberts's populist approach had a naive quality, wholly English and comparable, save for its lack of mysticism, with the work of *Stanley Spencer.

Of his official commissions, this portrait of T. E. Lawrence (1888–1935), hero of the war in the Middle East against the Ottoman Empire, is among his most important. Roberts first met Lawrence when he was recommended to illustrate his epic account of the war, *The Seven Pillars of Wisdom* (1926).

The portrait was exhibited, with Roberts's drawings for *The Seven Pillars of Wisdom*, at the artist's first solo show at the Chenil Galleries in 1923 (cat. no. 12 – 'not for sale'). It presents Lawrence with arms defiantly crossed, jaw set, eyes fixed, in the airman's uniform of the R. A. F. Lawrence had joined up in June 1922 as J. H. Ross, and rejoined in 1923 as T. E. Shaw. Painted in a rented room in Coleherne Terrace, Earl's Court, Roberts recorded that he would find his subject sitting on the dark stairs waiting for him if he was late. Sarah Roberts said that Lawrence preferred the unfinished portrait of himself by *John, also in the Ashmolean.

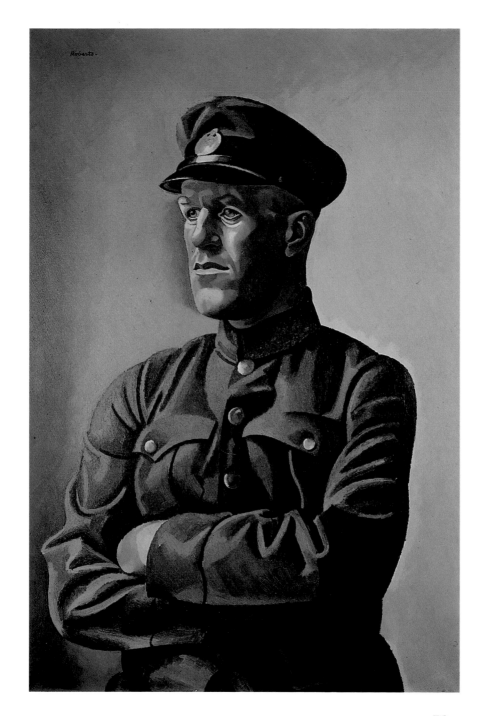

21 **Charles Ginner ARA** 1878–1952
 Cornish Cliffs mid 1920s
 Oil on canvas, 690 × 510
 Bevan Gift, 1957.17; A901

Born in France of Anglo-Scottish parents, Ginner train-
ed first as an architect in Paris. He then studied at the
Académie Vitti and at the Ecole des Beaux Arts. In 1910
he settled in London after exhibiting with the Allied
Artists' Association where his work had been spotted
by *Spencer Gore. He rapidly established a rapport with
*Gilman, Gore and *Bevan, and the following year be-
came a founder member of the Camden Town Group,
followed by the London Group and then the Cumber-
land Market Group, which met in Bevan's studio.
 In 1911 Ginner took Gilman to Paris and exhibited
with him in 1914 as a 'Neo-Realist'. The catalogue to
their joint show at the Goupil Gallery carried a mani-
festo for 'Neo-Realism' written by Ginner, published in
the *New Age* (Jan 1914). The manifesto was a stand
against both the painting of the Royal Academy, des-
cribed by Ginner as 'Academism', and less predictably
against Post-Impressionism which he saw as a new
academic movement in disguise, an art based on formu-
lae. His hero was Van Gogh, a 'great realist' with his
heightened palette, simplification and emphasis on
design.
 After the First World War, when he had been an
Official War Artist, Ginner's work became exclusively
devoted to landscape. He became the victim of his own
formulae, his unique style varying little. It is possible
that the deaths of Spencer Gore at the beginning and
more importantly of Gilman at the end of the war had a
stunting effect on his work, for while he continued to
paint until the end, and was made an Associate of the
Royal Academy in 1942, his style became increasingly
inflexible.
 This painting probably dates from the mid-1920s
when a number of cliff subjects of the Cornish, Dorset
and Isle of Wight coasts were exhibited by Ginner. It is a
good example of his mature style, with its careful con-
struction of the image from a mosaic of small touches of
thick paint, in which even the shadows are fractured
into patterns of colours. It also demonstrates his prac-
tice of using a viewfinder to establish an often idiosyn-
cratic composition, so that the picture frame dic-
tates the scene: the landscape itself has no start or end
point, no selection, having been 'cut down' as though to
fit the frame.

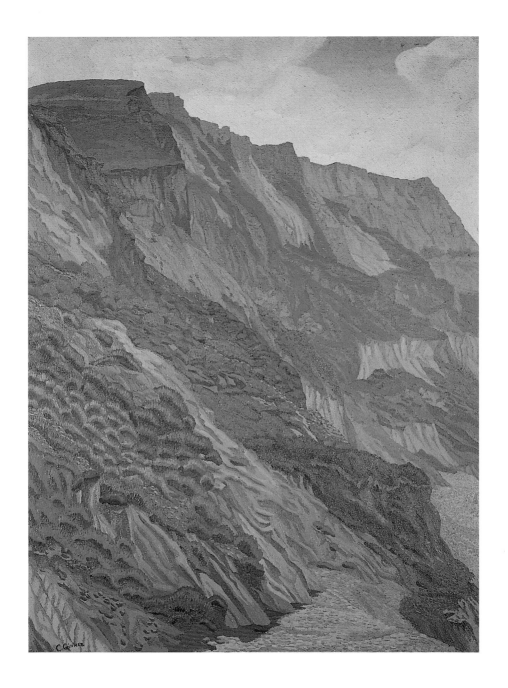

22 Matthew Smith 1879–1959
Flowers c.1925
Oil on canvas, 660 × 570
Bequeathed by Frank Hindley Smith, 1939
1940.1.8; A626

Smith was brought up in Halifax where he started work in 1900 in his father's wire-making business. Dogged as a young man by ill-health, Smith was allowed by his father to attend Manchester School of Art, as long as there were no female nudes in the life classes. At the age of 26 he entered the Slade, where he studied from 1905 to 1908. There he met Gwen John and Gwen Salmond, whom he later married. He spent a year painting at Pont Aven, from 1908 to 1909, and attended Matisse's school in Paris in the year before it closed in 1912. He settled in France until the outbreak of the First World War.

Wartime experience in the Labour Corps burying the dead had a traumatising effect, and Smith was finally invalided out with wounds. After the war he and his family returned to France, but Smith could not settle and spent the next few years a near recluse, in a state of deep depression both in Cornwall and London, painting melancholic landscapes in Fauve colours. Moving between London and Paris in the mid 1920s, he began the series of sensuous nudes which were to dominate his work. Later, he shared the model Sunita with Jacob Epstein, who, like *Augustus John, had been an early collector and life-long friend. In 1942 Smith and Epstein shared a retrospective exhibition at Temple Newsam House, Leeds, and in 1950 Smith represented Britain at the Venice Biennale. He was given a retrospective exhibition at the Tate in 1953, and was knighted in 1954.

Flowers dates from about 1925 when both his design and paintwork became more fluid. His first exhibition at the Mayor Gallery in April 1926 included half a dozen flower pieces, four of them entitled, simply, 'Flowers'. The Ashmolean oil is a good example of Smith's technique of painting direct from the subject, drawing in thin paint onto the blank canvas to organise the composition. Preliminary studies are rare in Smith's work, and his grasp of structure was weak. This spontaneity of paint, the embodiment of Ginner's 'Neo-Realism', suggests why Smith has been described as a 'painter's painter' and admired among others by Francis Bacon, who placed him alongside Constable and Turner in 'attempting to make idea and technique inseparable . . . a complete interlocking of image and paint.' As a colourist he was an inspiration to a younger generation of artists such as Patrick Heron.

54

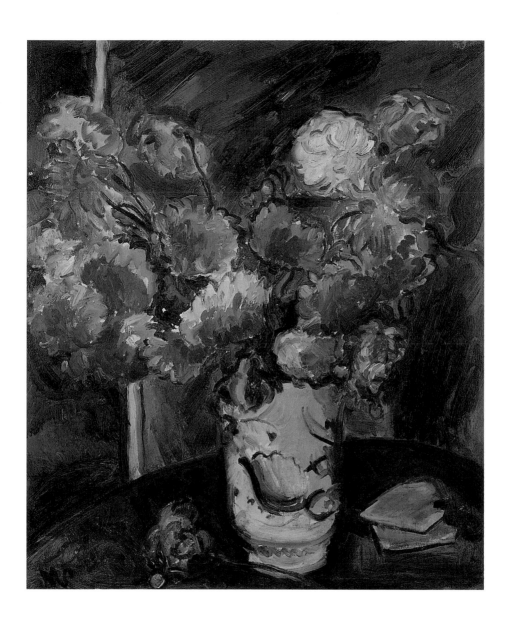

23　　**Ivon Hitchens** 1893–1979
　　　A Border Day 1925
　　　Oil on canvas, 560 × 610
　　　Bequeathed by Mrs Molly Freeman (née Mary
　　　Short), 1986, 1987.37; A1146

Hitchens, who was the son of the painter Alfred Hitchens, was educated at St John's Wood followed by the Royal Academy Schools, from 1911 and intermittently until 1919. A founder member of the 7 and 5 Society in 1920, Hitchens introduced *Ben Nicholson to the group in 1924, and stayed loyal to it until its demise in 1935. In the 1930s he, like Nicholson, was greatly influenced by *Braque. Bombed out of his Primrose Hill studio in 1940, Hitchens bought a gypsy caravan for £20, parked it in a thicket on Lavington Common, Petworth, and painted out the war in somewhat eccentric domestic discomfort.

After the war he undertook a number of murals, chief amongst them at St Luke's, Maidstone, St Paul's, Dorking, and All Soul's Freechurch, Golders Green. He was commissioned by the Arts Council in 1951 to paint an 18 feet long canvas *Aquarian Nativity – Child of this Age* (University College, London). This was an exceptional return to a figurative subject, for landscape was his inspiration, not the landscape of topography, but one of light and air in the sky, on water, of seasons, always verging on the purely abstract. Out in all weathers recording his sensations, Hitchens mixed musical and oriental ideas in a notational way in which calligraphic sweeps of the brush suggested the season, light, water and air.

A Border Day was painted while Hitchens was spending the summer of 1925 with Winifred and Ben Nicholson at Bankshead, near Brampton in Cumberland. It was exhibited at the artist's first solo exhibition at the Mayor Gallery in London that year under its present title. A label on the back, however, gives the title as 'Morning', and its price as 30 guineas, though it did not sell until after the exhibition when it was bought by Mrs Dudley Short. She subsequently gave it to her daughter, the painter Mary ('Molly') Freeman. The picture has had three further titles, 'A Border Morning', 'Morning, Bankshead' and 'Through the Window'.

The view from the window is an example of a motif that is common to a number of twentieth century British painters, notably the Nicholsons and their friend Christopher Wood. While *A Border Day* can be read as a view across a farmyard with sheds at right angles to each other, it is evident that this work is at the very edge of abstraction.

24 André Derain 1880–1954
Still-life with plums mid-1920s
Oil on canvas, 190 × 430
Bequeathed by Frank Hindley Smith, 1939
1940.1.20; A638

Derain met *Matisse while studying with Carrière in Paris in 1899 and soon after came to know Vlaminck also. Together they evolved a style which, when they exhibited together in 1906 as the Salon des Indépendants, earned them the name *fauves* – wild beasts. Derain soon repudiated Fauvism, and destroyed much of his work of the period. In its radical approach to colour and form however, Fauvism was extraordinarily influential, particularly in London in the two Post-Impressionist exhibitions organised by Roger Fry in 1910 and 1912, where it had a profound impact on British artists such as *Sickert and *Gore. In 1905 Derain had made his first visit to London and produced his series of paintings of the Thames. Later his ballet and opera designs made him popular in Bloomsbury and with the Sitwells. During and after the war he became a recluse at Chambourcy.

In October 1916 Apollinaire, in his introduction to Derain's solo exhibition at the Galerie Paul Guillaume in Paris, remarked on the painter's eager study of the Masters and declared that after youthful disaffections he had turned to sobriety and moderation. In 1913 Derain had embarked on the first of a series of still lifes, a subject he would return to across a long working life. All are characterized by being in the same plane. This is very apparent here where the dish of fruit conforms to the frieze-like formula and low-keyed tones of Spanish seventeenth century still lifes. In this Derain compares with *Braque. Both aim to establish the object in space, not by replication but by creating its reality in paint. Their ends and means were quite distinct however: the quality of paint in the one is fatty and liquid, in the other rough and dry.

25 Georges Braque 1882–1963
The Tobacco Packet (Le Paquet de Tabac) 1931
Oil on canvas, 260 × 370
Bequeathed by Frank Hindley Smith, 1939
1940.1.21; A639

By the 1930s Braque was a veteran of a number of radical art movements which had challenged and changed the nature of Western painting: Fauvism with its emphasis on fractured colour and Cubism with its exploration of fractured volume and space. Still lifes were the predominant though not exclusive objects of exploration, 'the illusion of a concrete object' as he put it. For Braque, like an earlier French painter of still lifes, J.-B. Chardin, the pursuit of representing the relationship between ordinary everyday objects was the motivating force – Braque spoke of the 'poetry' of the object.

There is an almost obsessive quality about the way in which Braque worked and reworked a group of objects, creating variations on a theme using the same things with slight rearrangements, slight re-emphases of the individual components, and juxtaposing them in this case against a *sgraffito* or scratched background. The ubiquitous pipe appears as early as 1906 and can also be seen in Cubist paintings of 1911 where the fragmentation echoes the normal fate of a white clay pipe, the sort that easily breaks into three. The pipe reappears in the still lifes of the 1930s where, with a glass and some fruit and the occasional packet of tobacco, whose distinctive hatched wrapper acts like some sort of measure, it is manoeuvred round the confines of a table-top. The series has the frieze-like quality and intimate intensity of a seventeenth century Spanish still life by Zubarán or Meléndez.

The Tobacco Packet was bought in London in 1934 less than three years after it was painted. On being bequeathed to the Ashmolean in 1939 it was the first Braque to enter a British public collection.

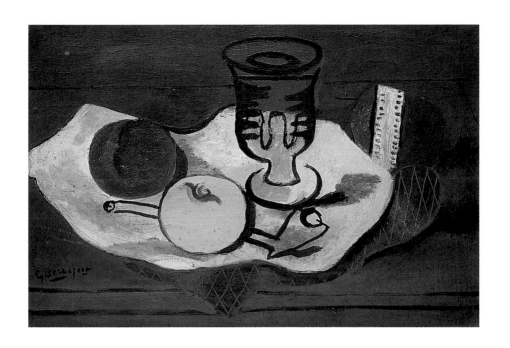

61

26 Augustus John OM RA 1878–1961
Villiers David 1932
Oil on canvas, 510 × 401
Presented by the executors of Gérard Schlup,
1994.141; A1192

Augustus John attended the Slade School from 1894 to 1898 where, under Frederick Brown and Henry Tonks, the emphasis on draughtsmanship encouraged John's natural facility for drawing. At its best, it achieved the vigour of Ingres and the economy of Matisse. John's was a precocious talent and, from 1901 to 1904, he was Professor of Painting at the University of Liverpool, and co-Principal of Chelsea Art School. In 1907 he went to Paris to see an influential exhibition of drawings by Puvis de Chavannes, and visited *Picasso's studio where he saw paintings of the Blue and the Rose periods and *Les Demoiselles d'Avignon* (1907, Museum of Modern Art, New York).

In 1910 John exhibited at the Chenil Gallery forty-eight *Provençal Studies*, painted at Martiques, which were immediately recognised for their radical approach to form and pure, vivid colour. A series of landscapes of Wales, Dorset and the South of France, painted in the company of J.D. Innes and Derwent Lees, followed. These small panels of fluidly brushed colour expressive of emotion for a place, may well have found their inspiration in *Kandinsky's landscapes shown in London in 1909. They were an exercise in the spontaneous use of paint, an apprenticeship which served John well when, post-war, he turned to portraiture. He was not a theorist or a joiner of groups, and his lifelong friendship with *Matthew Smith may well have had a foundation in this individualistic attitude and in their shared technique, both of them painting directly onto the canvas, without the use of preliminary drawings.

John's portraits, particularly those of literary figures such as George Bernard Shaw (c.1914) and Thomas Hardy (1923, both in the Fitzwilliam Museum, Cambridge), assume the quality of icons. Others, like the full length portrait of the cellist Madame Suggia (c.1923, Tate Gallery), are iconic in their own right, regardless of the identity of the sitter. John was elected Royal Academician in 1928. The epitome of the popular definition of the bohemian artist, John's reputation has suffered from the prolific numbers of society portraits that he painted, and from a scepticism about the facility with which he made them. This portrait of the poet, writer and painter Villiers David (1906–1985) is an example of the bravura of John's portraiture at its best and most incisive.

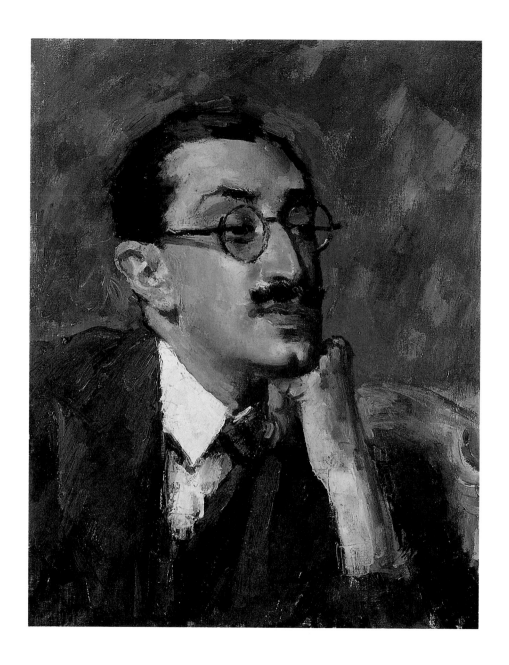

27 Stanley Spencer RA 1891–1959
Cows at Cookham 1936
Oil on canvas, 760 × 501
Bequeathed by Thomas Balston through the
National Art Collections Fund, 1968.27; A1044

Stanley Spencer was born the eighth of eleven children of William Spencer, upright, godfearing in the tradition of Bunyan, and organist in the village of Cookham, Berkshire. Rarely has an artist identified himself so completely with one place as has Stanley Spencer. Yet he was to say later 'it was when I painted what I had imagined that I came nearer to the feeling Cookham gave me.' He would go looking for a place and, not finding it, realise 'I had gone one better than Cookham in expressing this special atmosphere.'

As a prize pupil at the Slade from 1908 to 1912 he was known as 'Cookham' among his fellow students, who included *Bomberg, *Gertler, Paul Nash and *Nevinson. The Slade under Henry Tonks and the artistic ferment in London before the First World War had little effect on the direction of Spencer's development. What did have an impact was the outbreak of the war and Spencer's experiences first as a medical orderly and later on active service in Macedonia. He later blamed the war for throwing him off course and destroying his equilibrium and confidence in his inner vision. He exorcised its effects in an architectural scheme, initially purely imaginary, for a war memorial, the Sandham Memorial Chapel, Burghclere, Berkshire.

During the 1930s necessity demanded one landscape a week for Spencer's dealer Dudley Tooth. Throughout this time he nursed a project to create a 'chapel' celebrating peace, Cookham itself. Realised only in fragments, *Cows at Cookham,* owned from the first by Tom Balston, is an 'excerpt' from Spencer's imaginary chapel. It was described by Spencer as 'imagined as on the Moor', the open space between Cookham and Cookham Rise. The cows, with their cowgirl, swing solidly, rhythmically on, catching mouthfuls of grass as they go. The chestnut and may trees and the dandelion clocks announce Maytime, while Gemini-twins move with the startling speed and single-mindedness, characteristic of infants. Spencer cheerfully disregards the distortion of the countrywoman's legs as she lunges forward to catch her children. The painting records the evanescent pleasure of blowing dandelion clocks for small children; a paean to the joys of another spring, another generation.

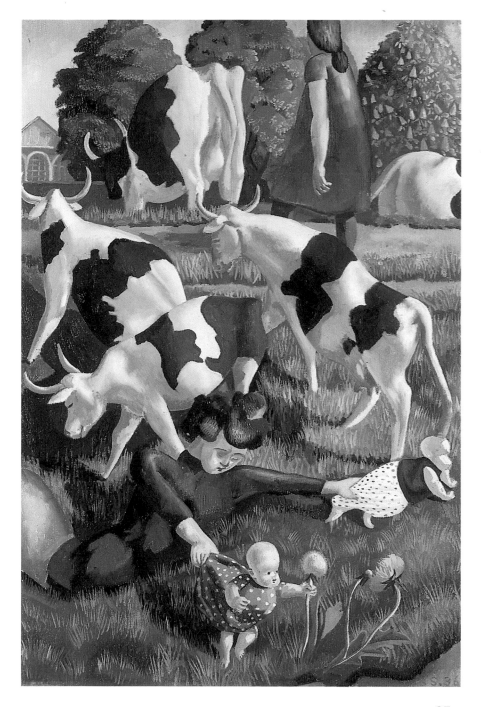

28 **Thomas Lowinsky** 1892–1947
Miss Avril Turner 1937
Oil on canvas, 450 × 340
Presented by Mrs Ruth Lowinsky, 1948.80; A766

Lowinsky was of Hungarian descent, his grandfather having left Hungary on the defeat of Kossuth's revolution in 1848. After Eton and Trinity College, Oxford, he went to the Slade from 1912 to 1914. There he made a lasting friend of his tutor Philip Wilson Steer, and met his fellow student and future wife Ruth Hirsch. He went through the war in the trenches unscathed physically, but emotionally scarred.

Lowinsky belonged to the same circles as Charles Ricketts, a lifelong friend and mentor, and *Glyn Philpot, but unlike theirs, Lowinsky's paintings were relatively unknown in his lifetime. Like Philpot, however, he produced penetrating likenesses and pursued symbolist and later proto-surreal subject matter from biblical and mythological sources. His first and only exhibition, with Albert Rutherston at the Leicester Galleries in 1926, had an introduction written by Edith Sitwell. Throughout the 1920s and 30s Lowinsky was better known as a whimsical illustrator for the luxury book market than as a painter.

On the outbreak of the Second World War Lowinsky retired to Garsington Manor, near Oxford, and, overcome by depression and the loss of his eldest son in action, ceased to paint. Perhaps because he did not have to earn his living by exhibiting or selling pictures, Lowinsky was far from prolific. His technique was meticulous and slow – he never worked on more than one canvas at a time, and each took months to complete. He worked straight onto the canvas without preparatory drawings, with an obsessive attention to detail in a manner resembling tempera.

This portrait is one of a series begun in the 1930s when Lowinsky turned from imaginitive figure compositions to portraiture, just at the moment when his friend Philpot went from portraiture to the fantastic. His sitters were usually, as here, hired models, and all have pursed lips and a bored attitude. We know nothing of them but their names and what the painter shows us. They have the same deliberate, passive quality and surface finish as an Ingres. Strangely disconcerting in their detachment and intimacy – Freud with clothes on – Lowinsky's portraits capture an attitude which not even the thimbleful of crème de menthe, itself a period detail, is going to change.

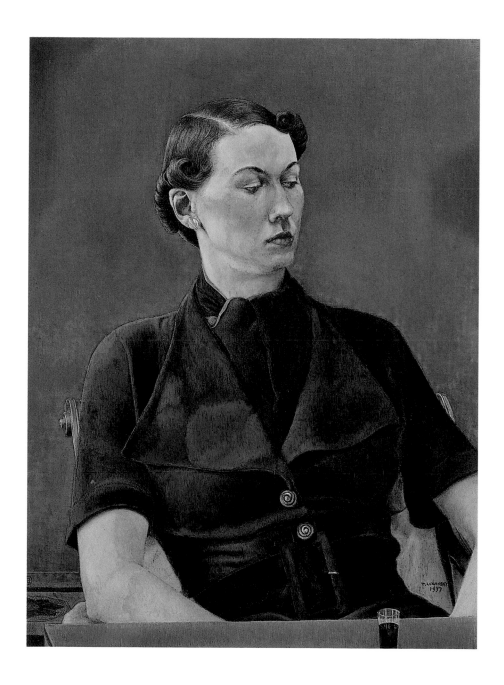

29 **Victor Pasmore RA** 1908–1998
Snow Scene 1944
Oil on canvas, 459 × 611
Presented by John Dodgson, 1948.69; A755

As a clerk in the London County Council Health Department, Pasmore attended evening classes at the Central School of Arts and Crafts from 1927, and studied the Impressionists, Turner and Cotman in museums. He joined the London Artists' Association in 1932 and the London Group two years later. As a member of the Objective Abstractions Group in 1934 with *Nicholson and William Coldstream he experimented with abstraction.

With help from Kenneth Clark he gave up his clerical job, and co-founded, in 1937, 'The Euston Road School'. This defined an approach and style which was a response to social responsibilities and an identification with everyday life. In 1939 he tried to register as a Conscientious Objector, deserted his regiment, was court martialled and imprisoned. On his release in 1942 he moved to Riverside Mall, Chiswick, then to Hammersmith Terrace, where he began a series in which he searched for the structure underlying things.

Snow Scene was presented to the Museum only four years after it was painted. This inconsequential backview from Hammersmith Terrace records the clutter of sheds, and the silence associated with snow fall, its transience and fragility on winter branches. Pasmore observes the rhythms of nature and explores the geometry of composition, from hedges, branches, tennis court fencing, glazing bars and roof lines in a series of patterns that hint at the pure abstraction to come.

In 1948 Pasmore moved irrevocably into abstraction, and became the champion of British modernism with a revolutionary series of spiral paintings. His new approach to art attempted to create a form no longer dependent on nature, but instead on a limited language of circle, square and spiral. Contact with *Nicholson and Barbara Hepworth at St Ives, and the writings of Gabo and Biederman were crucial catalysts.

In the post war years Pasmore taught at Camberwell and the Central School, and at Durham and Newcastle, where he became Consulting Director of Urban Design for Peterlee New Town, Co. Durham. He was selected for the British Pavilion in the 1960 Venice Biennale, and elected Royal Academician in 1983. Gradually the severity of the work of the 1950s and 60s gave way to a lyricism whose calligraphic style had a more organic, even oriental quality. This was entirely suited to printmaking, which became his preferred medium.

30 Ben Nicholson OM 1894–1982
Still Life, 1945
Oil on canvas laid on board, 170 × 240
Bequeathed by Professor Stuart Piggott, 1996
1996.459; A1202

Nicholson was a member of a successful dynasty of artists, the son of William Nicholson and Mabel Pryde. He attended the Slade School between 1910 and 1911, but continued to paint still lifes in his father's highly polished manner inspired by Velázquez. In the 1920s, living part of the year at Bankshead near Brampton, Cumberland, with his first wife the painter Winifred Nicholson, he developed a faux-naive, or 'primitive' style of landscape. Invited by *Ivon Hitchens to join the 7 and 5 Society in 1924, Nicholson became its chairman from 1926, and took the society, which by 1935 included Moore, Hepworth and *Piper, to the extremes of abstraction.

This tiny painting has a strength beyond its size and scale. Nicholson claimed it to be a 'most stimulating experience' to go from 'v. small to v. large or vice versa'. Wartime meant that horizons shrank, in Nicholson's case to the literal horizon of St Ives Bay outside his window. The bay is expressed with the utmost economy by means of a line which exactly describes the promontory beyond. Like *Braque, whom he had visited with Hepworth in Dieppe in 1932, Nicholson worked with a limited number of familiar objects, returning to them in his still lifes at different periods. He had as early as 1916 established an interest in jugs, mugs, cups and particularly their handles. The mug on the right appears to have been a favourite, a traditional 'Mocha' ware glazed in sandy beige, pale blue and black, colours in harmony with the land, sea and sky of Cornwall.

Nicholson had been intrigued by the potential for shadow in his plaster reliefs of the 1930s, and here the bold blackness of the vessels' shadows create an illusion of depth and suggests a three-dimensionality hovering between naturalistic reality and abstraction. The addition of the child's celebratory Union Jack in a number of still lifes of this period firmly anchors them in history, while the handle of the smaller cup raises a subliminal question mark over the future. A group of these wartime still lifes were illustrated in *Horizon* (September 1945). This particular work was exhibited the following month at the Lefevre Gallery (cat. no. 75), and was bought by Stuart Piggott when an undergraduate at St John's College, Oxford. Piggott became Abercromby Professor of Prehistoric Archaeology at the University of Edinburgh, retiring to Oxfordshire in 1977.

31 **John Piper** 1903–92
 June Landscape 1964
 Oil on canvas, 915 × 121
 Presented by Lord and Lady Franks, 1969
 1969.138; A1056

Piper set out as an articled clerk in his father's firm of solicitors in Westminster. On his father's death in 1924 he gave up the law and attended first Richmond and then the Royal College of Art. There he studied painting, lithography and stained glass, three media which consistently gained his interest in a long working life. He met *Braque in London in 1927 and later in Paris in 1933 when he also met Léger and Brancusi. Back in England, fully committed to Constructivism, he exhibited with the 7 and 5 Society. In 1937 he married Myfanwy Evans, who had founded *Axis*, the English magazine dedicated to abstract art. Influenced from boyhood by the *Highways and Byways* series of guide books, illustrated by F.L. Griggs and others, his source of inspiration was landscape, and more particularly architecture in landscape. Piper's strong topographical sense, an interest in the 'exact location and its spirit', made him a natural choice for the *Shell Guides*, and he was commissioned by John Betjeman to create the edition on Oxfordshire (1938). He contributed to the Pilgrim Trust's 'Recording Britain' scheme, begun in 1939, and worked as an Official War Artist during the Second World War.

During the war Piper designed the front cloth for a revival of Edith Sitwell and William Walton's *Façade* (1942). Thereafter a stream of collaborative works linked him with the post war renaissance in opera and ballet. His collaborations with Ashton, Cranko and Britten, including Britten's *The Rape of Lucretia* (1944) and *Death in Venice* (1973), for which Myfanwy wrote the lyrics, received international acclaim.

The destruction of churches during the war gave a renewed impetus to Piper's early interest in stained glass, and brought about a long and fruitful collaboration with Patrick Reyntiens. One of his most delightful commissions, *The Nativity* (1982), in which the creatures speak Latin, was set up in Iffley parish church in 1995.

Though the Ashmolean has important holdings in works on paper by Piper, given by Rena and Robert Lewin in 1992, it has only this painting. *June Landscape* echoes the strong, highly coloured tones of his stained glass programmes of the 1950s and 60s. In its light-hearted evocation of summer heat and colour, it is about mood rather than place.

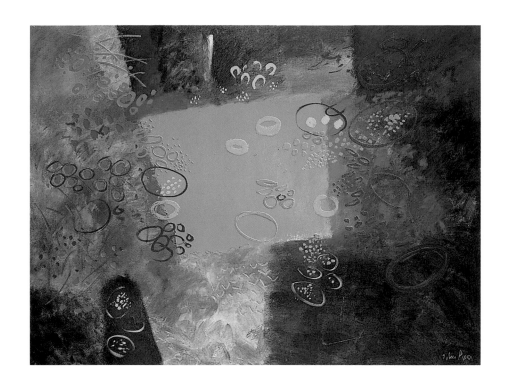

32 **Charles Marq** b. 1923
 Antichambre 1977
 Oil on canvas, 810 × 650
 Christopher Hewett Collection. Presented by the
 sisters of Christopher Hewett, 1987.138; A1153a

Marq approaches his work as a painter from two distinct points: philosophy and music. As a young man he graduated from the Sorbonne with a degree in philosophy, and in 1945 co-founded the Société de Musique Italienne with the musicologist Pierre Bonnard at Reims. In 1949 he married the painter Brigitte Simon, whose work is also included in the Hewett Collection, and entered the employment of his father-in-law Jacques Simon in the oldest and most important glassworks in France, at Reims.

There he worked on the restoration of war-damaged glass of the twelfth century at Saint-Rémi, and elsewhere in the Ardennes, and worked with Jacques Villon, Marc Chagall, *Braque, Poliakoff and Raul Ubac on programmes of new stained glass. He continues to restore old and design new glass, and has contributed etchings to numerous *livres d'artiste*. In 1976 he illustrated Walter Strachan's *Poems*. He has received national honours, notably the Grand Prix National des Métiers d'Art (1990, with Brigitte Simon) and became a Commandeur des Arts et Lettres (1992).

Marq's early paintings owed much to the influence of Giacometti, and while the figurative element became absorbed into space, the low-key, almost monochromatic palette abides. Unlike almost all the painters discussed in this book, Marq has declared that he sets out to exclude the familiar, and with an austerity of palette and motif to explore 'lumière as a living force, at once unitive [sic] and vital.' It is an entirely Gallic approach to the aesthetic, cerebral, economic and ascetic, explained in the language of mysticism and meditation, poetry and philosophy. These are two-dimensional conceptual constructions, as the poet François Chapon explained, intended to create a pure manifestation of space, an 'inner room'. *Antichambre* was one in a series concerning refracted light exhibited at Christopher Hewett's Taranman Gallery in 1978, for which it was reproduced on the cover of the catalogue.

33 **David Tindle RA** b. 1932
Head Study 1955
Oil on canvas, 245 × 145
Presented by the artist, 1993.541; A1188

Tindle was born in Huddersfield and went to the Lanchester College of Art in Coventry from 1945 to 1947. He earned his living at the time as a scene painter for the Coventry Belgrade Theatre, and as a commercial artist. In the early 1950s he moved to London and taught at Hornsey College of Art and subsequently at the Royal College of Art from 1972 to 1983. During this period he worked on a set of murals for the Open University, Milton Keynes (1977–8), and in 1979 was elected a Royal Academician. He became Ruskin Master at the Ruskin School of Drawing, Oxford, in 1983, a post he held for two years. In 1983 he was one of four artists featured in a BBC television documentary 'A Feeling for Paint', in which he demonstrated the painstaking skill of painting with egg tempera. Since 1990 he has lived and worked in France.

Tindle's early landscapes in watercolour were heavily influenced by the work of *John Piper. His later work, however, often atmospherically charged interior scenes characterised by an absent presence, is akin to photo-realism, his intensity of observation almost amounting to obsessiveness. *Head Study* belongs to a group of small oils which has affinities with contemporary paintings by his friend John Minton and *Lucian Freud in its claustrophobic intensity of observation. In its sombre palette it owes something to the post-war urban realism of the so-called 'Kitchen Sink School'. *Head Study* was included in the survey exhibition 'British Painting 1952–1977' held at the Royal Academy in 1977 to celebrate the Queen's Silver Jubilee.

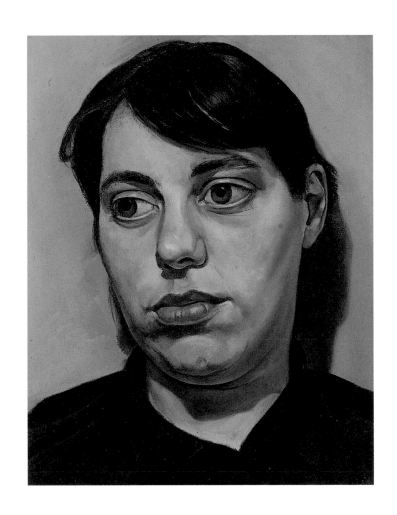

34 Lucian Freud b. 1922
Small Naked Portrait 1973/74
Oil on canvas, 220 × 270
Purchased with the assistance of the Victoria and
Albert Museum Purchase Grant Fund and the
National Art Collections Fund, 1988.229; A1157

Lucian Freud, grandson of Sigmund, refugee and un-
likely pupil of Cedric Morris, saw Roland Penrose's
International Surrealist Exhibition in London (1936) at
the age of 14. He was unavoidably impressed. 'Surreal'
is a word that has hovered irritatingly about Freud's
work ever since, as explanation for a body of work
which has developed according to its own logic, without
reference to the mainstream in postwar British art.

The very word 'naked' in the title is indicative, for
this is no nude in the tradition of Etty, *Bonnard or *Ma-
tisse, but rather an uncompromising statement about
the nature of Freud's painting. It is a subject to which he
has, from the early 1960s, returned with regularity. The
female figure, painted asleep in the foetal position, is at
her most vulnerable and exposed, and stripped of all
glamour. The forensic intensity of the painter's gaze
bounded, on this near miniature scale, by the heavy
black seventeenth century-type frame, converts the ob-
served body into a still life. The deep sense of intimacy is
devoid of all eroticism, and while the sitter may, indeed
certainly does, mean something to the painter, the spec-
tator is excluded from that relationship making the
sense of intrusion all the more intolerable.

There is more than a link in the bare rooms, un-
made bedsteads, naked women and London settings in
Freud's painting with the Camden Town Group. If *Sick-
ert's *Ennui* describes a common human experience of
bonded detachment, the paradox in Freud is that he
brings it to us, we are both together and at a distance
with the painting, at once compelled and repelled.

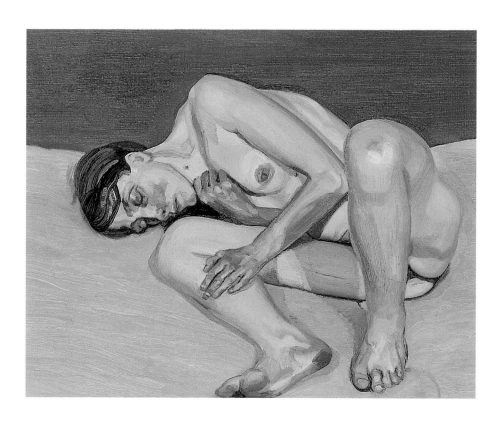

Select bibliography

Banham, M. and Hiller, B. (eds.): *A Tonic to the Nation – The Festival of Britain 1951*; London, 1976

Baron, W.: *The Camden Town Painters*; London, 1979

Cork, R.: *Vorticism and Abstract Art in the First Machine Age*; 2 vols, London, 1975–76

_____ *A Bitter Truth – Avant-Garde Art and the Great War*; New Haven and London, 1994 (exh. cat.)

Edinburgh, Scottish National Gallery of Modern Art: *The Romantic Spirit in German Art 1790–1990*; 1994 (exh. cat., ed. Keith Hartley)

Gruetzner Robins, A.: *Modern Art in Britain 1910–1914*; London, 1997 (exh. cat.)

Hughes, R.: *The Shock of the New – Art and a Century of Change*; London, 1980

Huxley, P. (ed.): *Exhibition Road – Painters at the Royal College of Art*; London, 1988 (exh. cat.)

London, Arts Council: *Landscape in Britain 1850–1950*; 1983 (exh. cat.). Essays by F. Spalding and others

London, Fine Art Society: *John Dodgson – Paintings and Drawings*; 1995

London, Royal Academy: *Post-Impressionism – Cross Currents in European Painting*; 1979 (exh. cat.)

_____ *British Art in the 20th Century*; 1987 (exh. cat., ed. Susan Compton)

London, Tate Gallery: *Abstraction – Towards a New Art – Painting 1910–20*; 1980 (exh. cat.)

_____ *Forty Years of Modern Art 1945–1985*; 1986 (exh. cat.)

Rothenstein, J.: *Modern English Painters*; 2 vols, London, 1952 and 1955

_____ *British Art Since 1900*; London, 1962

Salmon, J.: *A Century of Art in Oxford 1891–1991*; Oxford, 1992

Shone, R.: *Bloomsbury Portraits*; Oxford, 1976

Spalding, F.: *British Art Since 1900*; London, 1986

Sutton, D. (ed.): *The Letters of Roger Fry*; London, 1972 (2 vols)